PATRICIA FIELD ART COLLECTION
THE HOUSE OF FIELD
パトリシア・フィールド・アートコレクション「ハウス・オブ・フィールド」

目次
CONTENTS

「ハウス・オブ・フィールド」展
2023年6月3日(土) — 2024年5月6日(月)
中村キース・ヘリング美術館
主催：中村キース・ヘリング美術館
特別協力：パトリシア・フィールド・アートファッション
後援：米国大使館

The House of Field

June 3, 2023 — May 6, 2024
Nakamura Keith Haring Collection
Organized by Nakamura Keith Haring Collection
Special Cooperation by Patricia Field ARTFashion
In Association with U.S. Embassy Tokyo

表紙：
マーティーン
《ナメんなよ》制作年不詳

Cover:
Martine
I'll Kick Your Ass, N/D

ごあいさつ

KAZUO NAKAMURA

中村和男

中村キース・ヘリング美術館 館長
Founder of the Nakamura Keith Haring Collection

私が初めてパトリシア・フィールドを知ったのは、2009年にニューヨークのキース・ヘリング財団を訪問した時のことでした。その時、パトリシアのレーベルである「ハウス・オブ・フィールド」から、ヘリングのアートを使ったファッションラインを発表するということを知りました。数日後に、彼女のハウスパーティーに招待されて初めてお会いした日のことを鮮明に覚えています。バワリー通りにあるご自宅兼ショップは、むき出しのレンガの壁がネオンや装飾品、そしてファッションとアート作品で埋め尽くされていて、家というよりは煌びやかなラウンジでした。パトリシアは奥で大勢のファッショニスタたちに囲まれタバコをふかしながらくつろいでおり、舞台の上でスポットを浴びて妖艶なオーラを漂わせ、不屈不撓のクイーンの有様でした。

2016年にパトリシア・フィールドが長年続けてきたショップを閉店するという知らせを聞き、私はすぐにパトリシアが集めてきた膨大な数のアートコレクションを引き継ぎたいと申し出たのです。ショップに出入りする駆け出しのアーティストや、行き場のない若者たち、アメリカ国内だけではなくヨーロッパやアジアから「ハウス・オブ・フィールド」に憧れて集まってきた多種多様な人々により生み出された作品群です。作者不詳の作品も含め、現在彼らの中にはショップにいた当時とはまったく違う仕事に就いている方や連絡が途絶えた方、亡くなった方もいるでしょう。しかし、ショップに展示された作品群は豪放かつ純粋で、その独創的な表現は一度見たら忘れられない魅力があり、時空を超えて輝き続けているのです。彼らの人生と歴史、そして「ハウス・オブ・フィールド」が築いた時代を凝縮するアートコレクションを、この美術館を通して後世に伝えていけることを誇りに思います。

It is with great excitement that I introduce the Patricia Field Art Collection. I first discovered Patricia through a chance encounter in New York back in 2009, when I was visiting the Keith Haring Foundation. That's when I learned about her launching a collection of clothes using Haring's art. I was immediately struck by her unique sense of style and her unbridled creativity. At a house party she hosted, I had the privilege of meeting Patricia in person, surrounded by a lively crowd of fashion enthusiasts. Her Bowery home, with its exposed brick walls, neon lights, and eclectic decor, was the perfect backdrop for this unforgettable experience. I will never forget Patricia, looking like royalty with a cigarette in hand, as she held court over the gathering of artists and trendsetters.

In 2016, when Patricia's boutique was closing its doors, I knew that I had to preserve her collection of works by aspiring artists, struggling youths, and fans from around the world. These pieces are a true testament to Patricia's influence and the spirit of the House of Field. The collection is full of dynamic and raw expressions that capture the history and energy of the House of Field, and I am honored to pass on the future generations and share it with you through this collection.

I'm so happy that my collection is in Japan at the Nakamura Keith Haring Collection. Through the years, I have spent much time in and around Tokyo, developing wonderful friendships with artists and fashion people. One of my closest Japanese friends was Masuko Kato, who made Tokyo for me — a home away from home. In addition, this includes Mr. Kazuo Nakamura, who built his beautiful museum and who would come to New York on a regular basis and visit my shop.

With my wonderful Mr. Nakamura experience, I am overjoyed by the fact that he decided to exhibit a major portion of my art collection of New York City creative artists and characters of that time of my life. I hope all who visit the museum to see this exhibition will enjoy it.

My thanks to Kaoru, Masayo, Hiraku, Reiko, Shiho, and everyone at the Nakamura museum who helped me a great deal in this presentation.

私のアートコレクションが中村キース・ヘリング美術館に収蔵されていることを、とても嬉しく思っています。長年の間、私は東京という場所でアーティストやファッション関係の人たちと素晴らしい関係を築いてきました。なかでも親しい日本人の友人の一人である倍子は、私にとって東京を第二の故郷にしてくれました。また、輝かしい美術館を建て、ニューヨークの私の店にもよく来てくれている中村和男館長もその一人です。

そんな中村館長との歴史もあり、彼が今回、ニューヨークのアーティストやキャラクターが集まった、私の人生でもあるコレクションからたくさんの作品を展示すると決断してくれたことに、喜びが溢れています。美術館に訪れてくれた皆さん、ぜひ楽しんでください。

最後に、この展覧会に関わった薫、雅代、ヒラク、レイコ、紫穂、そして中村キース・ヘリング美術館の皆さんへ感謝を込めて。

Installation View

THE *HOUSE OF FIELD*

ハウス・オブ・フィールド

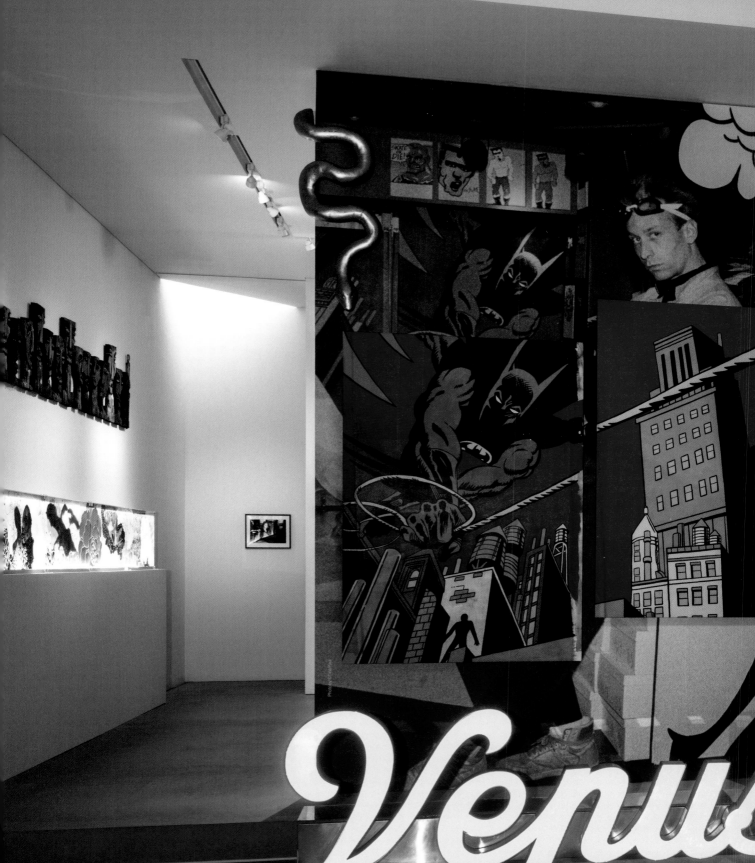

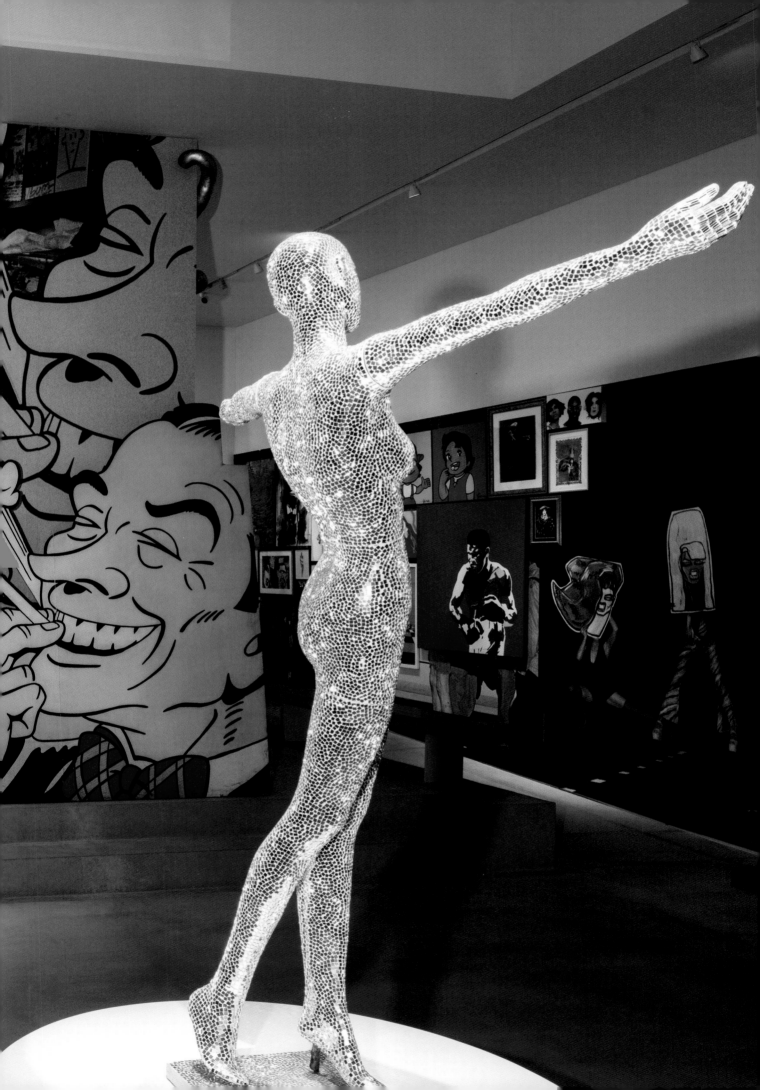

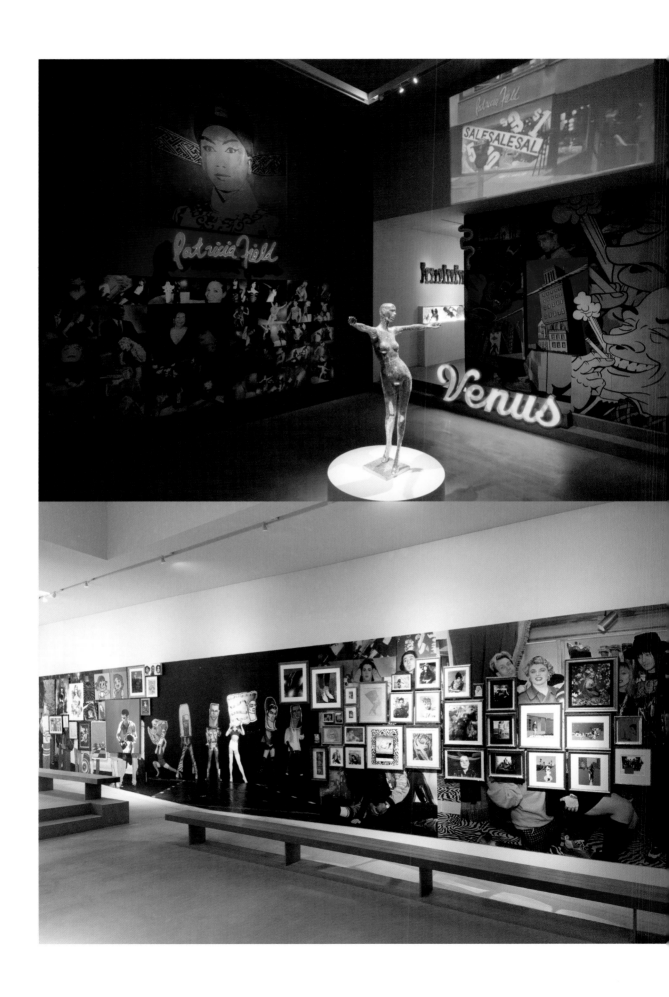

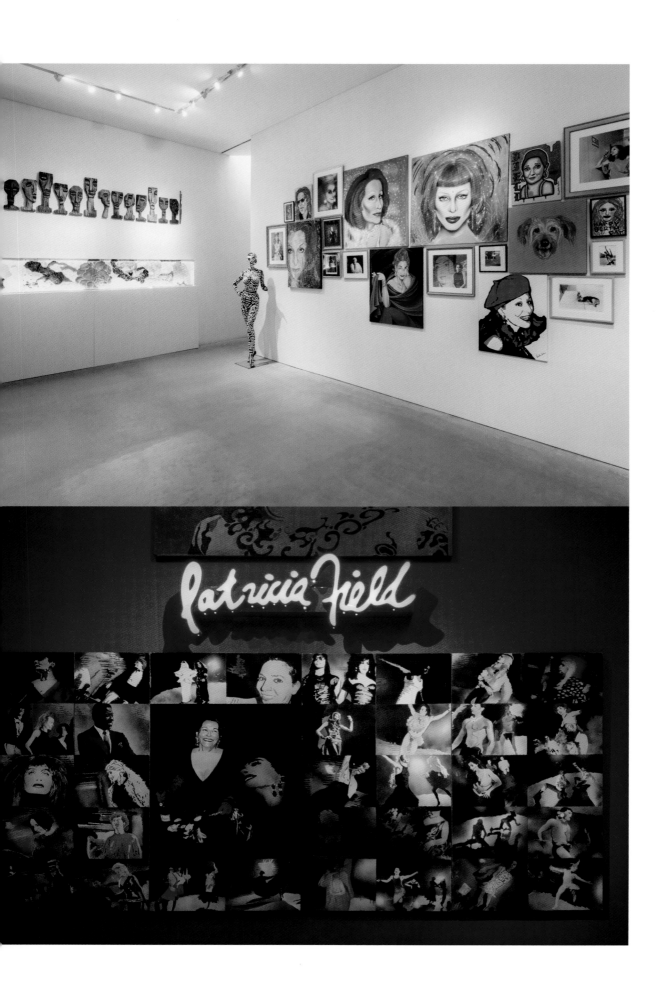

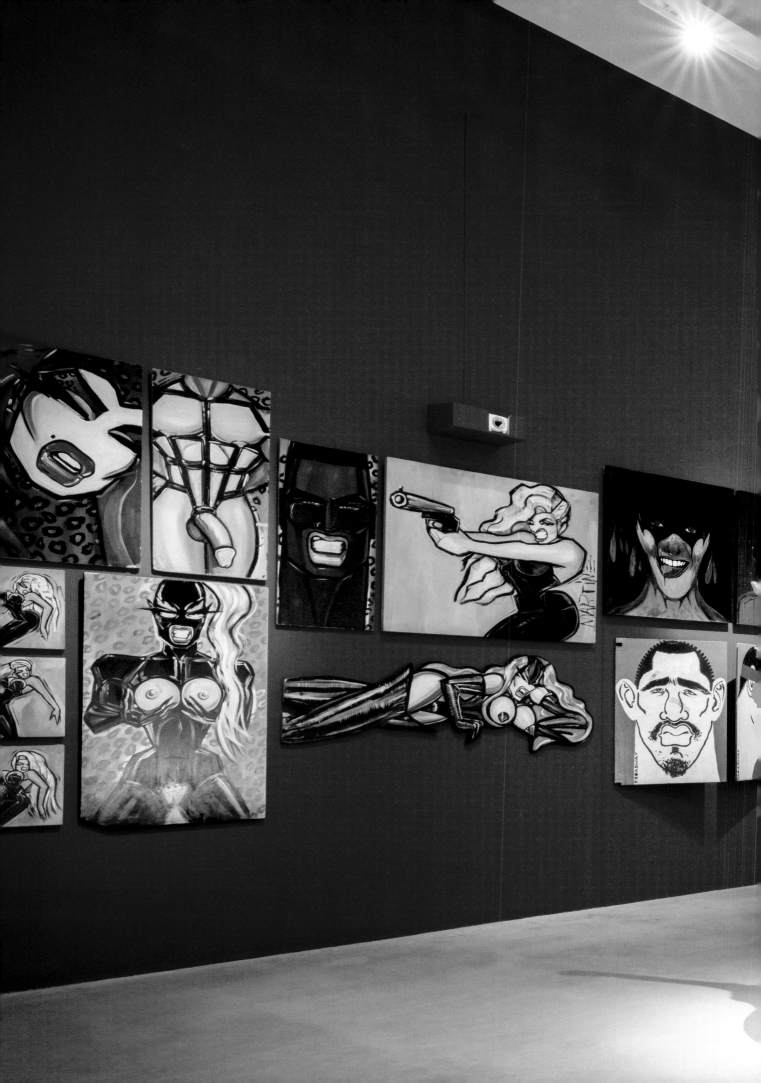

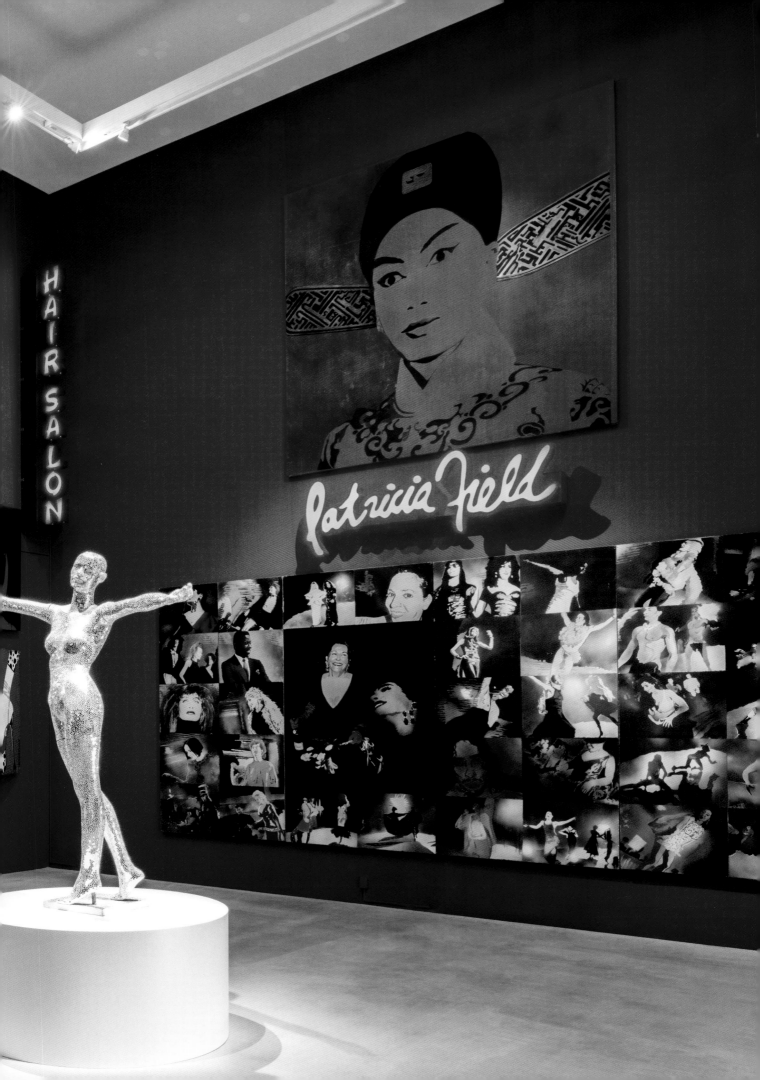

Chapter 1:
THE HOUSE OF FIELD
ハウス・オブ・フィールド

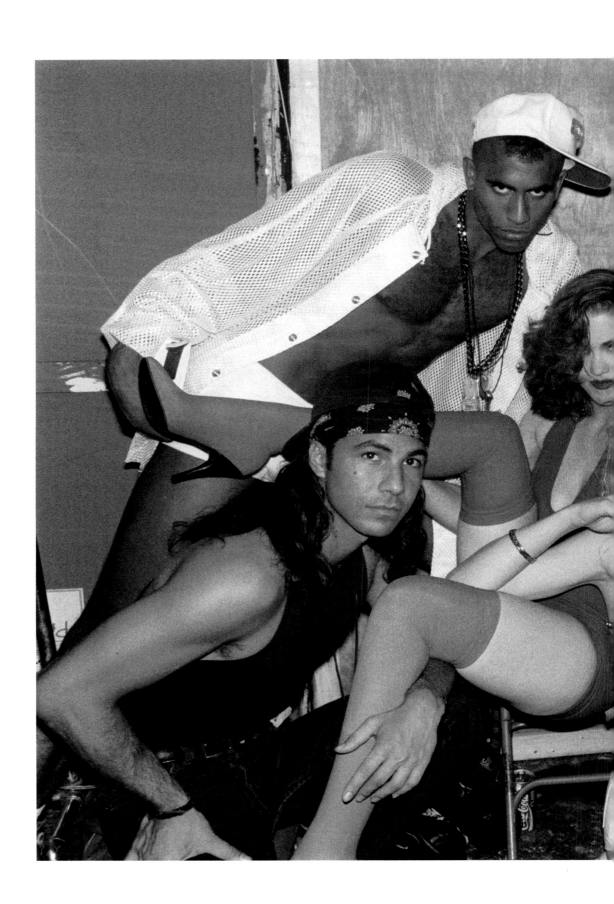

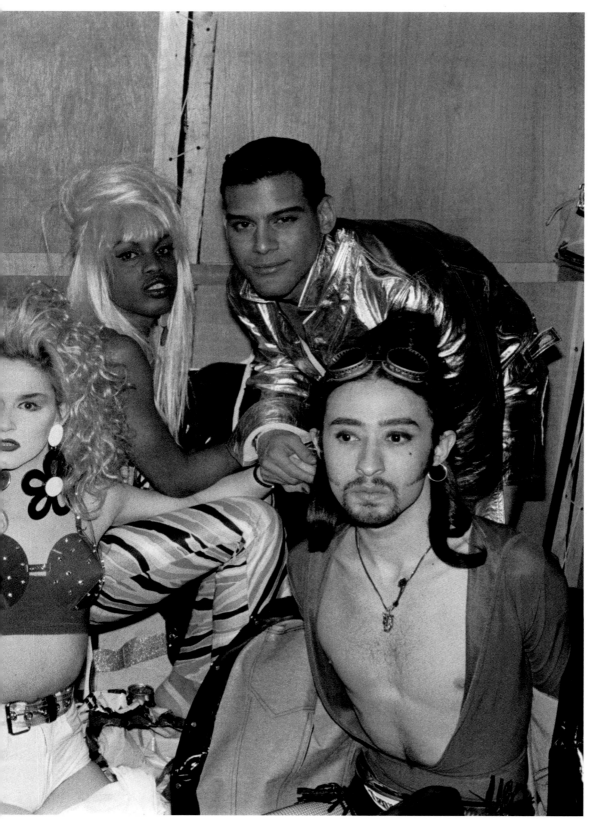

House of Field - Martine, Derek Smith, Becky Bombkemp, Codie Ravioli, Connie Girl, Atilla Lakatoush, Jojo Americo at House of Sweet Charity Ball at Palladium, NYC 6/12/90

アートとファッションの交差点

KAORU
YANASE

梁瀬薫

美術評論家／展覧会プロデューサー
国際美術評論家連盟米国支部会員
中村キース・ヘリング美術館顧問

1985年草月会館で開催された「アート・イン・アクション」展のアシスタントでケニー・シャーフやナム・ジュン・パイクをはじめ80年代の現代美術作家たちとの出会いがきっかけとなり、86年ニューヨーク近代美術館（MoMA）のプロジェクト「Projects 3: Justin Ladda」のアシストでニューヨークへ渡る。
90年代はじめから98年まで美術出版社ニューヨーク支部で海外情報事業に携わり最先端ニューヨーク美術の動向を発信。その後もコンテンポラリーアートを軸に数々のメディアに寄稿、執筆、翻訳、コンサルティング、展覧会プロデュースなど幅広く活動。2007年から中村キース・ヘリング美術館の顧問就任。

舞台はダウンタウン・シーン

2016年から中村キース・ヘリング美術館に収蔵されているパトリシア・フィールドのアートコレクションは絵画、写真、彫刻、オブジェ、ポスターなど現在はおよそ200点に及ぶ。そのほとんどはニューヨークのダウンタウンにあったフィールドのブティックに飾られていたものだが、正確なコレクション数は不明だ。ブティックや自宅に飾りきれない膨大な数の作品と資料は倉庫にも保管されていた。しかし2012年にニューヨークを襲った気象史に残るハリケーン・サンディで倉庫が浸水し、多くの作品が被害にあった。キース・ヘリングによる80年代初期のオリジナルポスター、ツェン・クウォン・チの写真作品から彫刻やキャンバス作品など修復可能な作品を残し、多くの作品は廃棄せざるを得なかった。中でもファッション写真界の巨匠ブルース・ウェーバーとフィールドが1985年にコラボした際に制作されたポスターや写真作品の消失には悔いが残る。まだゲイがタブー視されていた社会で男性ヌードを広告に起用したイメージは、当時の時代背景を象徴する華麗にも精強な作品だったからだ。

コレクションにはこのように歴史に残る著名なアーティストの作品だけでなく、ブティックに出入りしていた駆け出しのアーティストやダンサー、モデル、学生、中には住所不定者など職業も人種も国籍も異なる、ノンバイナリーもLGBTQも含め、まさに多様性を極める人々のあらゆるジャンルのアートが集まっていた。その舞台は1966年に初めてニューヨーク大学のワシントンスクエアパーク東側にオープンしたブティックから1971年に8丁目（10 East 8th Street）に移動し、ショップ名を「パトリシア・フィールド」としてオープンしたブティックに遡る。70年代のニューヨークは金融危機と犯罪率の高さで取り返しのつかないほど衰退していたにもかかわらず、ヒップホップが誕生しグラフィティアートが地下鉄や街中の壁を染めていた。アーティストたちは美術館やギャラリーではなく、新しい表現の場を求めてダウンタウンにやってきたのだ。ファッション、ミュージックが混ざり合ったブティックやクラブ、地下鉄、そしてストリートが舞台だった。70年代後半にはジェニー・ホルツァーが格言をもじったポスターをロウアーマンハッタン中に貼り、Tシャツや帽子に印字するという行為は歴史に残る活動であり、多くのアーティストがそれに続いた。ダウンタウンのパトリシア・フィールドのブティックもある意味ではオルタナティブなアートスペースの走りだったのだ。ブティックは常にアートがファッションと展示されていて、ジャン＝ミシェル・バスキアの紙製のジャンプスーツやTシャツが展示され安価で販売された。そしてパティ・スミス、マドンナ、デボラ・ハリーやキース・ヘリングなど後に名を上げるアーティストたちも出入りするようになっていた。キース・ヘリングの日記にもこのことが記述されている。
「パトリシア・フィールドのジャン（SAMO）の窓を見ている。描写された箱。描写された服。ラックに下がっている絵を見る。僕は洋服屋にある絵画作品を見るのが好きだ。パトリシア・フィールドのSAMOを」[1]。

ダウンタウンに集まるアーティストは誰もが規則に縛られない刺激的な表現を探索していたのだ。美術館や画廊は一般的ではなく上流階級と一部のインテリが行く特殊な場だったし、人種の坩堝といわれるニューヨークのアート界でも白人男性主義がまかり通っていた状況ではストリートアートの出現も必然的な流れだったといえよう。「私にとってファッションは絵画や音楽や文学と同じようにアートなの。オーガニックで自由であるべき。私の店はクラブの昼バージョンという感じで、集まってきた若者はみんな個性的で魅力的だった。バスキアは私のロフトで床やいろんな物に描いていたり、店ではペイントした服やTシャツを販売したり、彼は自分の思うままに何にでも描写していた。キース・ヘリングの反アパルトヘイト

Christmas Eve party at Patricia Field loft at 10 East 8th Street, NYC 12/24/91

の活動（1985年）を助けるためもあってTシャツを作りここで販売したことも
あったし、今思えばヘリングは私が知っているどのアーティストより公平で
誰にでも優しかった。彼が私のために窓に描いてくれた絵は割れてしまっ
たけれど、記憶から消えたことはない」とフィールドは回想している2。

アートのメッカ、ソーホーからロウアーイーストサイドへ

1996年にブティックは8丁目からソーホーに移り「ホテル・ヴィーナス」と
してオープンした。ソーホーが最先端のアートの街として沸いていた時だ。
同店でもアートがファッションと並んで繰り広げられていた。一方でアメ
リカ現代美術シーンは、マルチメディア・アートなる視覚だけでなく聴覚
や触覚も含む複合的な芸術の時代となっていた。例えば最新の現代ア
メリカ美術の傾向を映し出すホイットニー美術館バイエニアル展の
1995年度の展示が複合的なアートを展開していた3。政治や社会的な
メッセージ、メタファーやテクノロジーよりは、オーガニックな絵画作品や
大規模なインスタレーション、そしてLGBTQのサブカルチャーやHIV・
エイズの危機を探求する写真家ナン・ゴールディン、クイアのセクシュ
アリティーを堂々と表現したキャサリン・オピーなどが紹介された。特にマ
シュー・バーニーは注目を浴びた一人だった。もともとアメフト選手で
ファッションモデルの経験もあるというバックグラウンドで、ビョークとのコ
ラボや美容整形用の素材で作られる作品や人体をテーマにした斬新
な映像作品『クレマスター4』が話題を集め、アートに新しい可能性を示
した。2006年にバワリー通りに移転したブティックではフィールドが映画
やテレビのスタイリングに多忙を極め、ブティックにいることが少なくなって
いた背景もあり、アーティストが屯して作品を披露するようなことは減っていっ
たが、8丁目とソーホーのブティックにあった多くの作品が壁面に展示さ
れた。ポール・チェルスタッドの80年代のキャンバス作品《シー・ペ

イ・プー》（p. 64）とマーティーンによる女性のボディーの作品（p. 80、81）
は特に印象的だった。

アメリカを恐怖に陥れた2001年9月11日同時多発テロ事件の翌年に開
催されたバイエニアル展4にも触れておこう。展覧会コンセプトはテロ事件
の前に形作られていたが、事件後アメリカで急激に高まった「愛国心」とは
関係のない、別の意味での精神性や60年代サイケデリック以降のアメリカ
の歴史が映し出されている。パフォーマンスとインターネット・アートを含む
ハイテクなマルチメディア作品が伝統的な絵画・彫刻作品と展示されて、
レトロとハイテク、現実と空想、客観と主観、感情と理性が随所で滲み出て
おり、約100名の参加者にアート集団、音楽家、建築家、DJが含まれてい
たのも斬新だった。そして、同展キュレーター代表のロウレンス・R・リン
ダーの序文の一節が2000年以降のアートシーンの行方を啓示している。
「作品が美術館の展示にふさわしいか否かという区分や境界線の根底は
何なのか。工芸、アウトサイダー・アート、ポピュラー・カルチャーといった
言葉の特質とは？ また、創造性が分類され、マーケティングされ、展示さ
れた中に、性差別、階級差別、人種差別の痕跡を見つけるには、どれだけ
目を凝らさなければならないのだろうか。〔中略〕本展はこれらの問いに答
えを与えるものではないが、扉を静かに開けて真にアートが前に向かうた
めの一歩なのだ」5。

2007年にバワリー通りにニューミュージアム・オブ・コンテンポラリー・アート
がリニューアル開館し次々にギャラリーがオープンすると、それまでドラッ
グやアルコール依存症患者、貧困層が多く治安の悪さで知られたこの
エリア（ロウアーイーストサイド）は、瞬く間にアートの先端を行くヒップな街
へと変わった。バワリーに移転した「パトリシア・フィールド」には2016年
に閉店するまで、これまで通りのファンやドラァグクイーンとセレブたちが
世界中から訪れた。

original painted photograph

available at

original T-shirt

TINA PAUL

Patricia Field

KEITH HARING

10 east eighth street, nyc

September, 1985 issue of the *East Village Eye*

ポップアートとファッションビジネス

60年代初頭アンディ・ウォーホル、クレス・オルデンバーグ、ジェームズ・ローゼンクイスト、ロイ・リキテンスタインらが大衆消費社会(広告、テレビ、コミック、映画、雑誌、報道など)のイメージを素材としたポップアートを盛り上げ、サイケデリック・ムーブメントがウィリアム・バロウズやアレン・ギンズバーグといったビートニク文学に端を発して視覚芸術の分野にも広がり、その後も社会に多大な影響を与えた。このアートコレクション全体にもポップアートの影響は少なからず見受けられるのだ。例えばスーザン・ピットの作品(p. 105)。アメリカの古いコミック・キャラクターがそのまま使われているが、ステージのような場面が設定されたようなスタイルを確立している。また、1980年代初頭にはコートにも描いた。歴史に残る展示会「タイムズスクエア・ショウ」(1980年)と自身もメンバーだった前衛作家集団Colab(Collaborative Projects Inc.)のショップ、アモーレストアで発表された。またスザンヌ・マルークのゴールドを背景にした肖像画《演説家—マルコム・エックス》(p. 91)などは、MoMAの収蔵作品としても知られるウォーホルの代表作《ゴールド・マリリン・モンロー》(1962年)をはじめとするセレブの肖像画を想起させる。黒人として描かれているケネディ夫妻の作品も興味深い。「私の絵は彼(ジャン=ミシェル・バスキア)とのカタルシス(感情の浄化)。著名な白人を肌の黒い真っ赤な唇で描く。一ドル札のワシントンとか。ニューヨーク・タイムズ誌の表紙になっていたジャンの顔を白く塗った」[6]というのがマルークの絵画作品の根底にある。

ウォーホルがキース・ヘリングのポップショップを芸術の活動として後押ししたことは知られているが、フィールドもまたアートとコマーシャルを初めから結合させていた。「ハウス・オブ・フィールド」のビジュアルを象徴するマーティーンのアートを使ったコカ・コーラのキャンペーンやポスター、それに多くのファッションアイテムともコラボを果たした。マーティーンの描写する女性は一貫してドラァグをイメージさせる。セクシーなボディーは屈強で極限なまでにグラマラスで、銃を片手に叫び声を上げているフィギュアはさながら、性差による不平等を排して女性の意識を転換させようと立ち上がる、フェミニズムのスーパーヒーローだ。社会に問題提起し人々の感情を動かすことのできるアートを商品化するアート思考だ。ウォーホルの著書『The Philosophy of Andy Warhol(ぼくの哲学)』(1975年)の引用はフィールドのアートビジネスに当てはまる。「金稼ぎはアートであり、また労働はアートであり、よいビジネスは最もよいアートだ」[7]。

生のアートバザールとアール・ブリュット

フィールドの膨大なアートコレクションの傾向は言い表せないほど千差万別だ。セレブやクラブキッズ、そしてドラァグクイーンたちが好むような個性的なファッション空間の中で主張している。「私のブティックはバザールのよう」[8]だと言うが、ここでは「バザール」は雑多な大市場ではなく、エキスポ(博覧会)的な意味に近いかもしれない。自宅のキッチンにあるトルコランプしかり、リチャード・アルバレスの花をモチーフにしたガラスの作品(pp. 48–50)やブティックに飾られていたアーロン・コベットのドラァグクイーンの華麗なポートレート(pp. 110–111)、色鮮やかなウィッグや天井から吊るされた巨大なオウムの彫刻オブジェ……。それらはギリシャ・ローマの時代から世界の中心地として栄華を極めたアジアとヨーロッパの接点であるイスタンブールのグランドバザールの光景と繋がった。

バザールで売られているラグや伝統工芸品、衣類、多彩なスパイスも含めて。

もう一つ、コレクションをユニークにしているのが作者不詳や無名作家による作品群だ。ファンたちによるドローイングや贈呈された写真などのほか、オークションやフェアで購入された作品もある。どれも形式にとらわれず発想力が際立つアートについて、美術史におけるアール・ブリュットの引用は理解の扉を少し開けることができる。フランスの画家で彫刻家のジャン・デュビュッフェは特定の流派に属さず、美術教育を受けていない人々や、子供、精神病患者の作品に惹かれて収集し、1945年にそのアートをアール・ブリュットと名付けたのだ。フランス語でブリュットは「生」という意味がある。デュビュッフェは流行や他者を意識せずに創作した「直接的・無垢・生硬」な芸術作品と提唱した[9]。1972年にはイギリス人評論家のロジャー・カーディナルがアール・ブリュットの英訳として「アウトサイダー・アート」を提唱し、その概念がアメリカにも普及した。ニューヨークでも1993年からこのアートに特化した唯一の「アウトサイダー・アート・フェア」[10]を開催している。40年代にはデュビュッフェの表現はアカデミックな芸術の動向に逆行するもので批判もあったが、アメリカでは新しいアートの領域は瞬く間に話題となった。ボーダーレスなグローバル社会においては多様性がもたらす革新的なジャンルで、その需要性も重要性も高くなりフェアの規模は年々膨らんでいる。例えばフィールドが旅行中に見つけて大変気に入り購入したという作者不詳の作品(p. 126–127)がある。画面には顔の色が違う人々の口からドル、円、ドイツマルクなど異なる貨幣記号がビームとなって飛び出ている。ディテールのない原始的なイメージを思わせる絵画はデュビュッフェの絵画作品とも通じる部分がある。説明をする必要のない、自由でルールなきアートはパトリシア・フィールドのアートコレクションの根本的な概念だ。近年美術界に変化をもたらしているメディア・アートやNFTアート時代に新しい舞台の上で「生」のアートとの対話が始まる。

注釈

1. *Keith Haring Journals* (Penguin Classics, 1997), p. 87.

2. フィールドと筆者の会話から(2023年2月17日)。

3. 2002 Biennial Exhibition: March 7-May 6. Lawrence R. Rinder (Whitney Museum Museum of American Art).

4. 2002 Biennial Exhibition: March 7-May 6. Lawrence R. Rinder (Whitney Museum of American Art), 2002.

5. Lawrence R. Rinder, "Introduction," *Whitney Biennial 2002* (Whitney Museum of American Art), p. 11

6. *Widow Basquiat: A Love Story*, Jennifer Clement (Broadway Books New York 2014), p. 152.

7. *The Philosophy of Andy Warhol*, Andy Warhol (Harvest, 1975), p. 92.

8. フィールドと筆者の会話から(2016年2月、2023年1月17日)。

9. *Art Speak*, Robert Atkins (Abbeville Press Publishers 2013), p. 71.

10. https://www.outsiderartfair.com/new-york

参考文献

The Downtown Book: The New York Art Scene 1974-1984 (edited by Marvin J. Taylor, Princeton and Oxford: Princeton University Press, 2006).
Judith E. Stein, *Eye of the Sixties* (New York: Farrar, Straus and Giroux, 2016).
Laura Mulvey, *Visual and Other Pleasures* (Bloomington and Indianapolis: Indiana University Press, 1989).

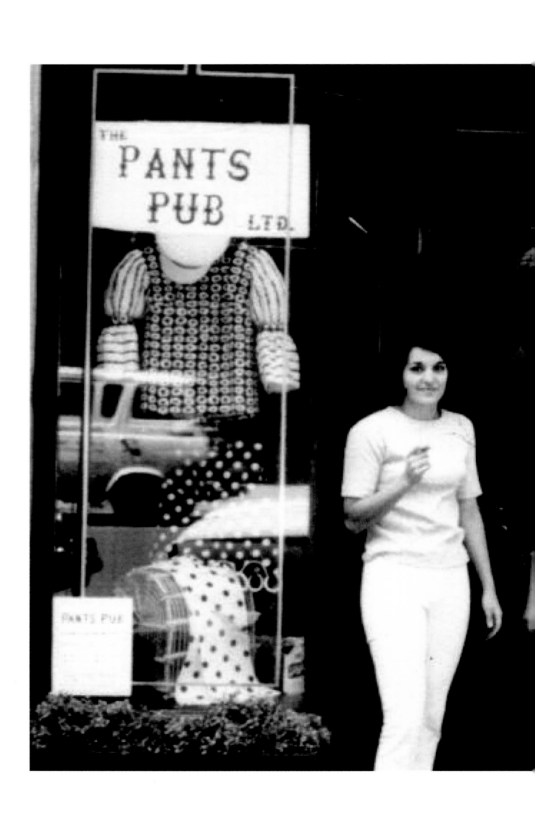

Jo Ann and Patricia Field at the Pants Pub.

The Intersection of Art and Fashion

KAORU YANASE

Art Critic / Exhibition Producer
AICA (Association of International Art Critics U.S.A)
Senior Advisor at Nakamura Keith Haring Collection

Assisted in the "Art in Action" exhibition at the
Sogetsu Kaikan in Tokyo in 1985, where she
met Kenny Scharf, Nam June Paik and other
cutting-edge contemporary artists of the 80's.
This encounter and the opportunity to assist
in the MoMA's *Projects 3: Justin Ladda*, led
her to move to New York in 1986.
From the early 1990s to 1998, she was put in
charge of the overseas information business
at the New York branch of Bijutsu Shuppan-
sha and has been active and involved in a wide
range of projects in the art fields. This includes:
writing, translating, consulting, and producing
exhibitions centered on contemporary art.
In 2007, she became a senior advisor to the
Nakamura Keith Haring Collection.

The Stage is the Downtown Scene

Patricia Field's art collection, which has been housed at the Nakamura Keith Haring Museum since 2016, includes approximately 200 paintings, photographs, sculptures, objects, and posters. Most of these objects were displayed in Patricia Field's boutique in downtown New York, but the exact number of works in the collection is unknown. A large number of works and materials that could not be displayed in the boutique or her house were stored away in a warehouse. However, in 2012, Hurricane Sandy, one of the largest superstorms in the history of New York City, flooded the warehouse and damaged much of the collection. Although many pieces, including original posters from the early 80s by Keith Haring, photographs by Tseng Kwong Chi, and sculptures and canvas works could be restored, many other pieces were damaged beyond conservation. It is particularly regrettable that posters and photographs produced as a result of Bruce Weber and Patricia Field's 1985 collaboration were destroyed.

In a society in which homosexuality was generally considered taboo, images of nude males in advertisements was a splendid and powerful visual statement that symbolized the milieu of the time. The collection includes artworks of all genres made by an extremely diverse group of people, including non-binary and LGBTQ+ people, and is not limited to the work of famous artists, but also fledgling artists, dancers, models, and students. The collection dates back to the boutique Field opened in 1966 at the New York University, east of Washington Square Park, which eventually moved to 8th Street (10 East 8th street) in 1971, and reopened as "Patricia Field." In the 1970s, New York was in a state of drastic decline due to the financial crisis and high crime rates. Simultaneously, hip-hop was born and graffiti art was painted across the subway system and the walls of the city. Artists ventured downtown looking for a new place of expression beyond museums and galleries, and fashion and music converged in boutiques, clubs, subways and streets. In the late 1970's, Jenny Holzer put up posters with quotes all over Lower Manhattan and printed letters on T-shirts and hats, a historic activity that inspired many artists who followed. Patricia Field's downtown boutique existed as an alternative art space in a way. Boutiques have always displayed art as fashion; Jean-Michel Basquiat's "paper" jumpsuits and T-shirts were exhibited and sold at low prices. Artists who would later become famous, such as Patti Smith, Madonna, Deborah Harry and Keith Haring, were coming and going. Keith Haring once wrote in his journal:
"I'm looking at Jean's (SAMO) windows in Patricia Field. Painted boxes. Painted clothes. Paintings hanging on racks. I like to look at paintings in clothing stores like SAMO at Patricia Field's."[1]

Artists gathering downtown were all searching for exciting expressions that were not bound by rules. Art museums and galleries were not "everyday" places, but special places where the upper class and some intellectuals gathered. In New York, which is said to be a mixed pot of races, white masculinity was prevailing even in the art world, so the emergence of street art was inevitable. It can be said that it was a natural flow.
Field described this flow in her own relationships to art and artists:
"For me, fashion is art, just like painting, music, or literature. Basquiat painted on the floor and other things in my loft. The store sold painted clothes and T-shirts. He painted whatever he wanted. Keith Haring's anti-apartheid activism (1985). I made T-shirts and sold them here to

Patricia Field, Asia Love, Keith Haring at Act-Up Party at Sound Factory, NYC 8/17/89

help out. Now that I think about it, Haring was more fair and kind to everyone than any other artist I know. The picture he painted for me on the window cracked. I have since lost it, but it never disappeared from my memory."[2]

From the Mecca of Art, Soho, to the Lower East Side

In 1995, the boutique moved from 8th Street to Soho and reopened as "Hotel Venus." It was a time when Soho was booming as the center of cutting-edge art. At the store, art was unfolding alongside fashion. On the other hand, the American contemporary art scene had entered an era of multi-media art that incorporated not only visual, but also auditory and tactile senses. The 1995 *Whitney Biennial*[3] reflected the latest trends in contemporary American art. Rather than focusing mainly on political and social messages, the Biennial featured metaphors on technology, organic paintings and large-scale installations, as well as photographs by Nan Goldin, who explored LGBTQ subcultures and the HIV/AIDS crisis, and works by Catherine Opie, who proudly presented queer sexuality, were showcased. Matthew Barney, in particular, was one of the highlights. With a background in American football and fashion modeling, Barney collaborated with Björk, made works using materials for cosmetic surgery, and created a stunning video titled *Cremaster 4* that focused on the human body, showing new possibilities in art. The boutique moved to the Bowery in 2006. During this time, Field was extremely busy with styling for movies and television, spending less time at the boutique, so the number of artists showing their work there decreased. However, many of the works from the 8th street and Soho boutiques continued to be displayed on the walls. Paul Cherstad's 80s canvas work *Shi Pei Pu* (p. 64) and

Martine's paintings (p. 80, 81) were particularly impressive.

It should be noted that the *Whitney Biennial*[4] was held the year after the September 11, 2001 terrorist attacks. The concept of the exhibition was developed before the attacks, and was not tied to the overt patriotism that surged in the United States at the time. Rather, a different sense of spirituality and American history — evoking the 1960s psychedelic movement was reflected in the exhibition. Multimedia works, including performance and Internet art, were exhibited alongside traditional paintings and sculptures, exuding retro and high-tech, reality and fantasy, objectivity and subjectivity, emotion and reason everywhere. It was also innovative in the sense that the approximately 100 participants included art collectives, musicians, architects and DJs. Lawrence R. Linder, the chief curator of the exhibition, predicted the direction of the art scene in the new millennium:

"What are the underlying categories and boundaries that determine whether a work is suitable for museum display or not? What are the characteristics of words such as craft, outsider art, and popular culture? This exhibition does not provide answers to these questions, but it does open the doors to the public. It's a step towards quietly opening and truly moving art forward."[5]

The New Museum of Contemporary Art opened on the Bowery in 2007, and art galleries opened one after another. The Lower East Side, which had been known for its lack of public order due to the high number of drug dealers and addicts, alcoholics, and the unhoused, quickly transformed into a hip area that was on the cutting edge of the art world. Patricia Field's boutique, which moved to the Bowery, was regularly visited by fans, drag queens and celebrities from all over the world until it closed in 2016.

Pop Art and the Fashion Business

In the early 1960s, Andy Warhol, Claes Oldenburg, James Rosenquist, Roy Lichtenstein and others produced pop art using images from mass consumer society, such as advertisements, television, comics, movies, magazines, news reports, and more. The psychedelic movement originated in the beatnik literature of William Burroughs and Allen Ginsberg, spread to the field of visual arts, and continued to have a great impact on society. The influence of pop art can be seen in no small part in Field's art collection as a whole — for example, in the work of Suzan Pitt (p. 105). Although old American comic characters are used as they are, they are presented within stage-like scenes. From around 1984, the images drawn on Pitt's coat are combined with more classical paintings. It caught the attention of the avant-garde artist collective Colab (Collaborative Projects Inc.), which organized the historical exhibition *Times Square Show* (1980), and were displayed at the groups' shop. They directly presented popular art, such as combining the logos of Coca-Cola and McDonald's with the painting *The Last Supper*. Additionally, Suzanne Mallouk's celebrity-style portraits of Black people against a gold background *ORATOR - MALCOM X* (p. 91) invoke portraits of celebrities such as Warhol's masterpiece *Gold Marilyn Monroe* (1962), which is in the collection of MoMA. The works which portray the Kennedys as black are also of interest. Mallouk described the fundamental underlying ideas of her own paintings:

"My paintings are a catharsis with him [Jean-Michel Basquiat]. I draw prominent white people with dark skin and bright red lips, like Washington on a one-dollar bill. I painted Jean's face, which was on the cover of the Times Magazine, white."[6]

It is known that Warhol promoted Keith Haring's Pop Shop as an art activity, but Field also combined art and commercialism from the beginning. Martine's art, which symbolizes the visuals of the House of Fields, was used in Coca-Cola campaigns and posters, and in collaboration with many fashion items. Martine's depictions of women are consistently associated with drag — the body is rugged and glamorous to the extreme, and the figure screaming with a gun in hand is like a feminist superhero standing up to end gender inequality and transform women's consciousness. It is a method of artistic thinking that commercializes art while raising social issues and moving people's emotions. A quote from Warhol's book *The Philosophy of Andy Warhol* (1975) applies to Field's art business: "Making money is art, working is art, and good business is the best art."[7]

A "Raw" Art Bazaar and Art Brut

The trends represented in Field's vast art collection are indescribably diverse, and make a statement in a unique fashion space favored by celebrities, club kids and drag queens. Fields says "My boutique is like a bazaar,"[8] but here the term "bazaar" may be closer to an expo, rather than a miscellaneous large market. The Turkish lamp in her kitchen, the flower-motif glass work by Richard Alvarez (pp. 48-50), Aaron Cobbett's gorgeous portraits of drag queens in the boutique (p. 110-111), vibrantly colored wigs and giant parrot sculptures hanging from the ceiling. They are reminiscent of sights from Istanbul's Grand Bazaar, which has been the center of the world since the Greco-Roman era, and is the point of contact between Asia and Europe, including rugs,

traditional handicrafts, clothing, and a variety of spices.

Another quality which makes the collection unique is the inclusion of works by anonymous or unknown artists. In addition to drawings and photographs presented by fans, there are also works purchased at auctions and fairs. A quote about Art Brut can open the door to understanding a little about art that is not constrained by formality and has outstanding imaginative power. Jean Dubuffet, a French painter and sculptor, did not belong to any particular school, and was attracted to the works of people without art education, children, and mental patients, calling it "Art Brut." *Brut* means "raw" in French, and Dubuffet advocated for a "direct, innocent, raw"[9] approach to art created without being conscious of trends or other people. In 1972, British critic Roger Cardinal proposed "outsider art" as an English translation of art brut, and the concept spread to the United States. In 1993, New York held the *Outsider Art Fair*,[10] dedicated to this type of art. In the 1940s, Dubuffet's expression went against the trend of academic art and was criticized, but in the United States, the new area of art quickly became a hot topic. In a borderless global society, it is an innovative genre brought about by diversity. For example, there is a work by an unknown author (p. 126-127) that Field found while traveling and liked it so much that she bought it on the spot. On the surface, different currency symbols such as the dollar, the yen, and the German mark (DM) shoot out as beams from the mouths of people with different facial colors. The figures, which are reminiscent of primitive images with no detail, have something in common with Dubuffet's paintings. Art free of rules that require no explanation is a fundamental concept of Patricia Field's art collection. In this current era of media art and NFT art, which has brought about changes in the art world in recent years, a dialogue with "raw" art begins on a new stage.

Footnotes

1. *Keith Haring Journals* (Penguin Classics, 1997), p. 87.

2. From the conversation with Patricia Field. February 17, 2023.

3. *Whitney Biennial 1995*: March 23-June 4, Kraus Kertess (Whitney Museum of American Art).

4. 2002 Biennial Exhibition: March 7-May 6, Lawrence R. Rinder (Whitney Museum of American Art), 2002.

5. Lawrence R. Rinder, "Introduction," *Whitney Biennial 2002* (Whitney Museum of American Art), p. 11

6. *Widow Basquiat: A Love Story*, Jennifer Clement (Broadway Books New York 2014), p. 152.

7. *The Philosophy of Andy Warhol*, Andy Warhol (Harvest, 1975), p. 92.

8. From the conversation with Patricia Field on February 2016 and January 17, 2023.

9. *Art Speak*, Robert Atkins (Abbeville Press Publishers 2013), p. 71.

10. https://www.outsiderartfair.com/new-york

Bibliography

The Downtown Book: The New York Art Scene 1974-1984 (edited by Marvin J. Taylor, Princeton and Oxford: Princeton University Press, 2006).
Judith E. Stein, *Eye of the Sixties* (New York: Farrar, Straus and Giroux, 2016).
Laura Mulvey, *Visual and Other Pleasures* (Bloomington and Indianapolis: Indiana University Press, 1989).

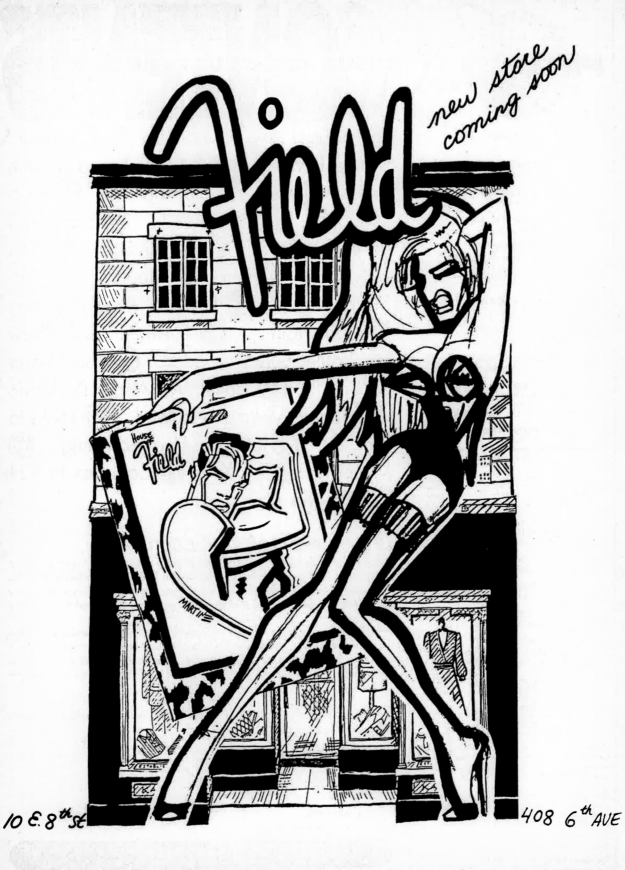

27

SANDALS

HOT!

david dalrymple for FIELD

382 W. Broadway, NY, NY

HOUSE OF Field

382 W. Broadway,

WORK!

'95 3 3

↑お店の顔的存在、アマンダさん。コ
スメも充実してます

世界のスーパースタイリスト

"Apparel is an expression of the environment around us . . ."
Patricia Field

SHAKESPEARE'S

Perfidia's Fairworld
at
Patricia Field
STEVEN (PERFIDIA) FIELD
8TH ST/UPSTAIRS

....Ne
A soup w

It doesn't exist unless there's a big ground situation. Underground is an outgrowth as an alternative to the mainstream. It could be Mafia. It could be club scene. I t could be many things. But, it exists because the traditional or the accepted way does not work for everyone. And, whoever is either on the short end of the stick or not inclined for whatever reason manifests into an alternative place which is the underground.

Field thrives after 'Sex'

August 2 ♥'95

PATRICIA FIELD
バトリシア・フィールド
ウエアはもとより、アクセサリーやランジェリー、コスメ
ティック、ウィッグバー、ヘアサロンなどが一体になった、
NYのクラバーご用達ショップ。

Perfidia's
Salon
Venus

MOVING!

'YOU DON'T
HAVE TO SPEND
A FORTUNE TO
LOOK GOOD'

Venus
ホテル
Venus
Broadway
York City, NY 10012
466-4066

Hit Me!

Patricia Field

NEW YO

...A multi-ingredient place with many tastes.

THE ONES
Flawless

虹色の日々 ニューヨーク

MASAYO KISHI

岸雅代

スタイリスト

日本育ち、ニューヨーク在住。
スタイリスト、ジェイソン・ファーラーの第一アシスタントを
経て独立。
2019年ポスターマガジン『PERMANENT PAPER』
創刊。
ラフォーレ原宿2022年秋冬〜2023年春夏ビルボード
／シーズン広告のクリエイティブディレクターを務める。

permanentpaper.us
masayokishi.com

30

8th Street

私が初めてニューヨークを訪れた1996年、パトリシア・フィールドは、ワシントンスクエアパークから近い8丁目に、路面店ブティック「Patricia Field」を構えていました。
階段を下りて半地下にあるドアを開けると、すぐ右手には小さなメイクアップセクションがあり、そこを抜けると右側に長い大きなキャッシャーカウンター、お店の中央から左側にかけてカラフルなトップス、スポーツトラックスーツ、ラインストーンドレス、ビートアップデニム、チャンキーアクセサリー、ペイントされたクラッチバッグなど、カテゴリー別に商品が綺麗に陳列されており、90年代にプラットフォームのウエッジサンダルで有名だったスカイシューズ、膝上ロングブーツなどが右奥の壁一面にざっと並び、さらに奥がボンデージセクション、レザー、ラテックス、ランジェリー、そして薄暗いフィッティングルームへと続いていました。
主な顧客はドラァグクイーン、ストリッパー、SM嬢、クラブキッズ、スタイリスト、ヘアメイクアップアーティスト、ファッションデザイナー、ミュージシャンで、えり好みする彼らの期待に応えるごとく、商品は元より、壁にはアートペインティング、ウィンドウには大きなウィッグと、奇抜でエッジなスタイリングのマネキンたちがディスプレイされており、さらにスタイリッシュでセクシー、ぶっきらぼうなセールス兼スタイリストのガールズたち、カラフルな照明、ソウルフルなハウスミュージックが加わり、「ザ・パトリシア・フィールド・ワールド」がそこに存在しました。キャッシャーカウンターに置かれた様々なパーティーフライヤーは、「Patricia Field」で働く厳しいドラァグクィーンたちの目によって選ばれた物のみであり、ハイプでトレンディなクィアコミュニティの、重要な情報の発信源となっていました。

当時、大ヒットドラマ『Sex and the City』はまだ始まっておらず、私はパトリシア・フィールド本人を、有名なブティックのオーナーだと認識していました。どこで彼女のお店を知ったのか覚えていないのですが、無意識に、しかし強烈にこのブティックに引き寄せられたことは覚えています。すでに様々なファッションフリークたちが世界中から訪れており、至って普通のジャパニーズツーリストだった私は、8丁目からお店の入り口が見えただけでも、緊張したのを覚えています。
半地下に下りようとした時、片手を腰に当て、ピンとした背筋でタバコを吸っているアジア人女性がいました。日本では見かけない長いアイライン、長い黒髪ポニーテール、確かスタイルは黒いボンデージルックだったと思います。ソーシャルメディアのない時代、平日の昼間のニューヨークで堂々と自身のスタイルを確立し、強いオーラを放っていたこの女性との遭遇は、私にとってセンセーショナルな出来事の一つでした。「日本人なのかな？そうだとしたら一体何者？！」── 脳内で独り言を言いながら、心臓の鼓動を感じつつも顔は平然を装い、彼女の前をゆっくり避けてお店のドアを開けました。この女性は当時「Patricia Field」の二階にあったヘアサロンで働いていた、日本人ヘアスタイリストのあゆみさんで、後に私の人生で初のグリーンヘアカラーを、彼女にお願いすることになるのでした。

洗礼

お店の中では、肌の露出多め70年代風タンクトップボーイと、昨夜のパーティーからそのまま出勤しているであろう、体格の良いスタイリストガールがペちゃくちゃ楽しそうに喋っています。勇気を振り絞り「試着をしていいですか？」と拙い英語で伝えたところ、笑いながら何かを言っています。しかし意味が飲み込めない私に、タンクトップボーイが黒目を回しながら「もう！あっちよ、あんた！」と顎を動かして指示してきました。振られた方向を見るとフィッティングルーム担当のスタイリストが、人差し指を動かして「こっちよ、ハニー」と私を呼んでいます。いそいそ向かっていくと、「勝

手にどうぞー！」と、クラブトイレ風の薄暗い小さなフィッティングルームに通されました。持ち込んだ洋服は赤いライトで照らされ、すでに何色だったのか思い出せず、そのうえ鏡は外にあり、近くで先ほどの彼女たちが、昨晩の出来事の続きをドラマティックに語っています。私にはフィッティングルームから外に出てその話を遮る勇気はなく、結局鏡を見ずに、商品を購買したことを覚えています。

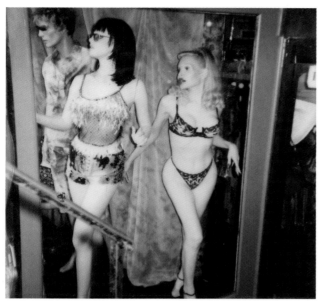

Amanda Lepore posing as a mannequin in the window of Patricia Field
(10 East 8th Street)

キャッシャーカウンターの中でレッドヘアのパトリシアが、店内で働くスタイリストたちに何かを大声で指示していましたが、全く動じず、そんな態度にパトリシアは全く気にも留めない様子で、彼女たちの間に上下関係があるようには見えませんでした。当時のナイトクラブやエッジなソサエティで自らのポジションを築くには、奇抜なスタイルと高飛車な態度はファッションの一つでした。そして流行りのクラブのエントランスは、彼女たちの判断と目利きで成り立っています。そして昼間はお店に立っているわけですから、もちろん日本のようなカスタマーサービスはありません。私もそれを承知で来ているわけです。
しかし買い物を済ませてお店を出ようとした時に、先ほどのタンクトップボーイが出口の私に向かって笑顔でウィンクし、「エンジョイ！」──一見硬くて青いけれど、食べたら甘酸っぱい果物のような、もしくは「終わり良ければ全て良し」ってこういうことだったのか。こうして「Patricia Field」in New Yorkのアメとムチの洗礼を受けてしまった私は、再びニューヨークに来ることを決めたのでした。現代だったら、レビュー欄は星2個となるのでしょうが、私には「Welcome to Downtown New York. Come back again if you dare!（ダウンタウンにようこそ、また来れるなら、いらっしゃいね）」と聞こえたのです。

ホテル・ヴィーナス

それから数年後、私はニューヨークに住み、すでに数人の著名スタイリストのアシスタントを始めていました。8丁目の「Patricia Field」と並行して、ソーホー地区のウエストブロードウェイに敷地面積も内容もさらにパワーアップした「Hotel Venus」をオープンしました。日本のブランド、ヒステリックグラマーやアッシュ＆ダイアモンド1なども並んでいたことを鮮明に覚えています。
ペイントされたレザージャケット、エクストララージサイズコルセット、実用的でないヘッドピース、ゴム素材のボディスーツ、ピエロのシューズなど、

皆が驚くようなアイテムをいつも探していた私には、「Hotel Venus」は唯一無二のワンダーランドでした。間違いなく全てのスタイリスト、スタイリストアシスタント、著名人、そしてパリス・ヒルトン、ブリトニー・スピアーズに至るまで、アメリカのファッション、エンターテイメントシーンには、なくてはならない場所になっていました。

実は、普段テレビドラマを見ない私は『Sex and the City』というドラマを全く知りませんでした。ある日、とあるスタイリストアシスタントの仕事で、初めてマノロ・ブラニク2のシューズを借りに行った時に、なぜマノロパンプスがここまで有名になったのか教えてもらいました。パトリシアの自伝にもあるように、このドラマはヒットするまではどこからも洋服が借りられず、わずかな協力者とセール品、サラ・ジェシカ・パーカーの若い勇気と好奇心、パトリシアのユニークなスタイリングで始まり、後に大ヒットするのです。マノロ・ブラニクは最初に協力したブランドの一つであり、このドラマがきっかけで"ハイヒールパンプスはマノロ・ブラニク"という不動の地位をアメリカに築いたのでした。

真っ白な見切り品のTシャツを大量に見つければ、それを買いしめカラフルな色に染め直し、新しい商品に変身させるでしょう。ラスベガスのドラッグストアでお土産を見つければ、もちろんヘッドピースに改造するでしょう。クイーンズのラテン地区で、若い少女がつけていたネームプレートネックレスを『Sex and the City』のキャラクター、キャリー用に作り、ドラマで使用した結果、即座にアップタウンガールズが真似し始めました。現在でも一番売れているアイテムだそうです。

彼女は直感にとても忠実です。アイデアを発信すれば常に話題になりました。ハイエンド、ロウエンド、アップタウン、ダウンタウン全ての異なるスタイルをシャッフルし、ニュースタイルとして開拓するパイオニアです。そして彼女の周りにはたくさんの優秀な仲間（チーム・パトリシア）が集っていました。私にとってはスタイリングのスキル以上に彼女の考えや存在自体が輝かしく映りました。幸い私の逆引き寄せが叶ったのか「Hotel Venus」の当時のストアマネージャーは、Tatsuyaという日本人だったこと、パトリシアはたくさんの日本のプロジェクトも抱えていたことが重なり、私にもスタイリストアシスタントの機会が与えられました。

当時、特にファッション業界では、自身が好んで修行としてアシスタントをしている場合、大御所の方でも無償でお手伝いすることが多々ありました。しかし、パトリシアに至っては、ポートフォリオの確認やトライアルもなく呼んでいただき、動いた時間に対して十分な報酬をいただいたことは、今でも感謝しています。履歴書を必要とせず、仕事を知人から紹介されるという責任もここで学びました。と同時に、「Hotel Venus」のガールズたちからは強いメンタルに鍛えていただきました。泣いたこともありましたが、今となってはとてもいい思い出です。

私が彼女から学んだスタイリングで最も印象的なのは、グラマラスな女性のスタイリングです。どんな個性的なキャラクターであっても、必ずベルトを使用し、ウエストのシェイプを作ります。ヒールを好むので、皆の姿勢が良いのです。と同時に、サスペンダーを前でクロスさせたりと、ルールを常に壊します。シンプルなドレスの上にコルセットベルト、皮のフィンガーレスグローブなど、最後には必ずパトリシア・フィールド・スタイリングに落ち着きます。実際は何度もやり直し、納得いくまで諦めません。そして決まった瞬間に「I love it! What do you think?...Well, I don't know anymore.（最高！あなたどう思う？うーん、もうわかんない）」と言い残し、タバコを吸いに行ってしまいます。

パトリシア・フィールドは時代と共に数々のプロジェクトを大成功させました。それは彼女と共に情熱を持って取り組むパトリシア・ファミリーの存在

なしには語れません。鋭い洞察力、素直で不器用、もしくは器用で粘り強い、時には気分屋、お洒落で愛らしい、強烈な個性、スペシャルで才能のあるキッズたちを、パトリシアは常に引き寄せ、発見し、助け、時を過ごし、共に楽しみました。常にオープンで好奇心があり、来る者を拒まず、そして全て自分のエネルギーに変えていく彼女。無名から著名まで、彼女がアート、ファッション、エンターテイメント業界にどれだけの貢献をしたかは計り知れません。大勢の日本人も魅了され、影響を受けましたが、パトリシアのアイデアの後ろには、たくさんの個性豊かで優秀な日本人がいたこともお伝えしておきます。

パトリシアのモットーは、高級品と、リーズナブルで若い人にも手の届くチープファッションのミックスです。そしてユニークな一点物、自ら見出した無名デザイナーのコレクションなど、世間に媚びることなくメディアに推奨しました。彼女は『Vogue』や『Harper's Bazaar』などのファッションマガジンが作り出すトレンドには、全く左右されない唯一のスタイリストです。テレビドラマでは20ドルのペイレス・シューソース3と、5000ドルのシャネルのジャケットを組み合わせました。なぜならそれがそのシーンにフィットしている、と彼女が思ったからです。
そのように自身の存在価値をファッションを通して表現し、ニューヨークから世界へと向かう、唯一無二の存在となりました。彼女はスタイリストという仮面を被ったダウンタウンの自由の女神なのかもしれません。もしパトリシア・フィールドと彼女のブティックが存在しなかったら、ニューヨークは太陽の出ない曇り空のような世界だったのではないでしょうか。

パトリシア・キッズ

パトリシア・フィールドのハウスからは多くのクリエイターたちが育っていますが、現在でも活躍するパオロとトベルは明記しておきたい存在です。

Paolo Nieddu　パオロ・ニエドゥ

今ではすっかり有名になってしまった、私の元ルームメイトでスタイリストのパオロ・ニエドゥは、ミシガン州のデトロイトからニューヨークに出てきたばかりの25歳の時、「Hotel Venus」の販売員となりました。その後パトリシアが担当したテレビドラマシリーズ『Ugly Betty』のアシスタントメンバーの一人として活躍後、独立。数々の映画祭のコスチューム部門でノミネートされています。最近では映画『The United States vs. Billie Holiday』でプラダと共にコスチュームを担当しました。パトリシアが最も誇るアシスタントの一人です。
彼がパトリシアから学んだことは、大胆なプリントや色の組み合わせだそうです。ストライプに水玉、サイズ違い、色違いの格子柄を重ねるなど。そしてどんなに夜遅くまでパーティーで踊っていても、必ず朝の6時にはスタジオに来て仕事をしていたそうです。アップタウンが『Vogue』のダイアナ・ヴリーランド4だとしたらダウンタウンはパトリシア・フィールドだと断言していました。
彼が初めて日本を訪れた時、原宿の竹下通りにある「ブティック竹の子」5というお店を見て、自分が働いていたソーホーの「Hotel Venus」時代を思い出したそうです。そしてなぜパトリシアは日本が好きで、たくさんの日本のアイテムを売っていたかも理解できた、と言っていました。

Tobell Von Cartier　トベル・ヴォン・カルティエ

そしてもう一人、ニューヨークのレジェンド・ドラァグクイーン、トベル・ヴォン・カルティエです。夜はニューヨークで最も有名なドラァグクイーン・キャバレー「Lucky Cheng's」でドラァグクイーンをしながら、昼間は「Patricia Field」「Hotel Venus」両店のヘアサロンでウィッグマスター

として働いていました。
当時では珍しいグリッターで光り輝いた硬いウィッグを、友人のブランド「The Blonds」のファッションショーで発表した時、フロントロウで見ていたパトリシアからその場で「お店でも扱いたいの、すぐに作って」とリクエストがきたそうです。その後、たくさんのヘアスタイリストや著名人がそのウィッグを求めてやってきたのは言うまでもありません。
現在、彼女は自身のアパレルブランド「Steven Davis New York」を立ち上げて活躍しています。もちろんパトリシアのギャラリー「ARTFashion」でも取り扱っています。

注釈

1. 1996年に加藤倍子が設立した元祖セクシーキラキラ系ガールズブランド。

2. スペイン出身の同名のデザイナーによって、1972年に設立されたイギリス発の高級靴ブランド。

3. 「一足買えば二足目半額」などかつて全米1だった大型ディスカウントチェーンストア。1956年創業、2019年に店舗閉鎖。

4. アメリカ合衆国のファッション雑誌『Harper's Bazaar』編集者を経て、『Vogue』編集長。1903年フランスパリ生まれ、1989年没。

5. 1979年オープンの原宿竹下通りにあるステージ衣装専門店。80年代のキャバレー、ディスコなどのオーダーメイド衣装から始まり、ブティック竹の子の衣装を着て踊る若者が「竹の子族」と呼ばれ大ブームとなる。レディー・ガガ、浜崎あゆみ、K-POPグループのスタイリストなどが来店し、創業44年の現在も地下アイドルのカスタムステージ衣装を手がけるなど、フル稼働中の唯一無二の名店。

Dequan at Hotel Venus, c. 2002

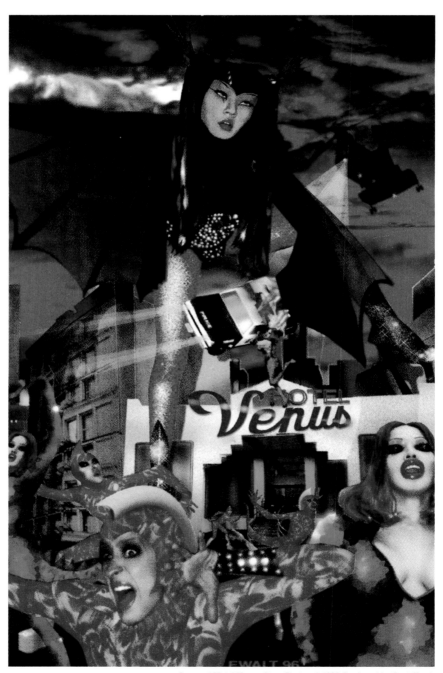

Scanned Hotel Venus Store Postcard, 1996, Designed by Scott Ewalt

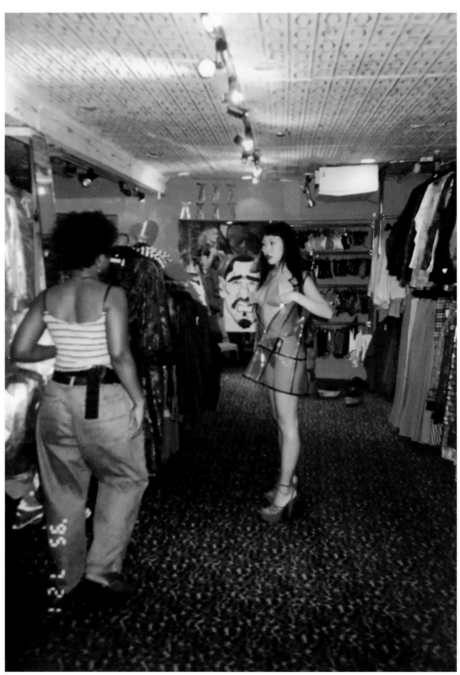

Ayumi at Patricia Field (10 East 8th Street), 1995

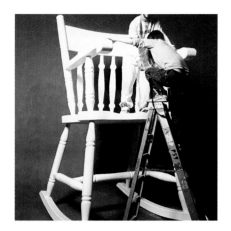

New York,
My Rainbow Color Days

MASAYO KISHI

Stylist

Born and raised in Japan, Kishi is now based in New York City.
After working as the first assistant to stylist Jason Farrer, she ventured into an independent career.
In 2019, she successfully launched the poster magazine **PERMANENT PAPER**.
Kishi has also taken on the role of Visual Director for billboards at Laforet Harajuku, overseeing the Fall/Winter 2022 to Spring/Summer 2023 seasons.

permanentpaper.us
masayokishi.com

8th Street

In 1996, when I first visited New York, Patricia Field had her eponymous street-level boutique on 8th Street, near Washington Square Park. When you opened the door and went down the stairs to the semi-basement, there was a small makeup section immediately to the right. Passing through the space, there was a long, large cashier counter on the right side, and colorful tops, sporty tracksuits, rhinestone dresses, beaten-up denim, chunky accessories, and painted clutch bags were neatly displayed in categories from the center to the left side of the store. Famous platform wedges known in the 90s as "sky shoes" and over-the-knee long boots were roughly lined up on the entire right rear wall, and further back was a bondage section, leather, latex, lingerie, and a dimly lit fitting room.

The main customers were drag queens, strippers, dominatrices, club kids, stylists, hair and makeup artists, fashion designers, and musicians. To meet their high expectations, not only were the products excellent, but art paintings adorned the walls, and large wigs and mannequins with eccentric and edgy styling were displayed in the windows. Furthermore, the stylish, sexy, and in-your-face drag queen sales staff-slash-stylists, colorful lighting, and soulful house music combined to create "The Patricia Field World."
Various party flyers placed on the cashier counter were chosen only by the discerning eyes of the strict drag queens working at Patricia Field, and it became an essential source of information for the fashionable and in-the-know queer community.

At that time, the hit TV series *Sex and the City* had not yet started, and I recognized Patricia Field herself as the famous boutique owner. I don't remember how I came to know about her store, but I do remember being unconsciously yet intensely drawn to this boutique. The boutique was already frequented by colorful "fashion freaks," but as an ordinary Japanese tourist, I remember being nervous just seeing the entrance of the store from 8th Street. Just I was about to go down to the semi-basement, I saw an Asian woman with one hand on her hip, smoking a cigarette with a straight back. She had long eyeliner and a long black ponytail, which I had not often seen in Japan, and I think her style was a black bondage look. In that era before social media, my encounter with this woman who boldly established her style and emitted a strong aura during a weekday afternoon in New York was a sensational event. "Is she Japanese? If so, who on earth is she?!" While talking to myself and feeling my heart pounding, I kept a calm expression on my face and slowly moved past her to open the store's door.
This woman was Ayumi, a Japanese hair stylist working at the hair salon on the second floor of Patricia Field at the time, and she would later give me the first-ever green hair color of my life.

The Baptism

Inside the store, a 70s-style tight tank top-wearing boy with a lot of skin exposed and a well-built stylist girl, who seemed to have come straight from a party the night before, were chatting happily. Gathering my courage, I asked in broken English if I could try on clothes, and they replied to me while laughing, but I did not understand it. The tank top-wearing boy, rolling his eyes, said, "Oh no, Miss Thing! Over

there!" and pointed with his chin. Looking in the direction he was gesturing to, I saw the fitting room staff member was waving her index finger and calling me over, saying, "Over here, honey." Hurrying over, I was ushered into a low-lit, small dressing room reminiscent of a club bathroom; she said, "Go ahead, help yourself!"

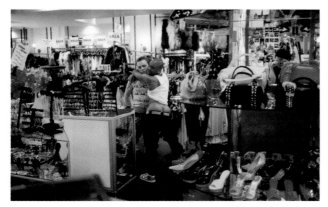
Paolo (Left) and Dequan (Right) at Hotel Venus, 2002

Inside the cashier's counter, red-haired Patricia was loudly giving directions to the stylists working in the store, but they didn't seem to be fazed, and there didn't seem to be any hierarchy among them. Patricia didn't seem bothered by such attitudes.

At that time, having an eccentric style and haughty attitude was par for the course to establish one's position in the edgy society and nightclubs. Admission to trendy clubs was determined by the judgement and discerning eye of the gatekeepers, who also worked in Field's store during the day. You could not expect customer service like that in Japan, of course — I knew that when I came to the shop. But when I finished shopping and was about to leave the store, the tank top-wearing boy from earlier winked at me with a smile as I approached the exit and said, "Enjoy!"

At first glance, the boutique seemed tough and unapproachable, but it was like a sweet and sour fruit when you tasted it, or perhaps it was a case of "All's well that ends well." Having experienced the carrot-and-stick baptism of Patricia Field in New York, I decided to come back to New York again. If this was in current times, perhaps the review section for the shop would have read two stars, but to me, it sounded like "Welcome to Downtown New York. Come back again if you dare!"

Hotel Venus

Several years later, I was living in New York and had already started working as an assistant to a few renowned stylists. Patricia Field had moved from 8th Street to West Broadway in Soho, changing its name to Hotel Venus and upgrading its space and content. I vividly remember that Japanese brands like Hysteric Glamour and Ash & Diamonds1 were also displayed there.

Painted leather jackets, extra-large size corsets, impractical headpieces, rubber bodysuits, clown shoes, and other over-the-top items were always sought after by people like me. Hotel Venus was a unique wonderland not only for me but for almost all stylists, stylist assistants, and celebrities, including Paris Hilton and Britney Spears. It had become a pivotal space within the American fashion and entertainment scene.

In fact, despite knowing about Patricia and her boutique, I had no idea about the show *Sex and the City*, as I usually didn't watch TV dramas. One day, when I went to borrow a pair of Manolo Blahnik2 shoes for an assistant stylist job, I was told why Manolo pumps had become so famous. According to Patricia's autobiography, before the show became a hit, it was hard to borrow clothes from anywhere. Before it became a major hit, the show started with a few collaborators, sale items, the young courage of Sarah Jessica Parker, and Patricia's unique styling. Manolo Blahnik was one of the first brands to collaborate with the production, and the show established the firm correlation of "high-heeled pumps equals Manolo Blahnik" in America.

If she found a large amount of white clearance t-shirts, she would buy them all, dye them in a variety of colors, and transform them into new items. If she found souvenirs in a Las Vegas drugstore, of course, she would turn them into headpieces.

In a predominantly Latino neighborhood of Queens, she had a nameplate necklace made for the *Sex and the City* character Carrie, which was similar to one worn by a young girl she saw. After using it in the show, uptown girls immediately started imitating it. It is still one of the best-selling accessory items to this day.

She is always faithful to her intuition. Whenever she shared her ideas, they always became a thing.

Patricia is a pioneer in shuffling different styles from high-end, low-end, uptown, and downtown to create new styles.

She was surrounded by many talented friends and family (Team Patricia). To me, her way of thinking and her very existence shone brighter than her styling skills. Fortunately, whether it was due to my reverse attraction, the store manager of Hotel Venus at the time was a Japanese man named Tatsuya, and Patricia had many Japanese projects as well. This led to an opportunity for me to work for her as an assistant stylist.

At the time, especially in the fashion industry, even prominent figures would often help out for free as an apprenticeship if they enjoyed the work. However, I am still grateful that Patricia called me without checking my portfolio or doing a trial and paid me adequately for the hours I worked. At the same time, I learned the responsibility that comes with being introduced to work through acquaintances without a resume. I was also trained to have a strong mentality by the girls of Hotel Venus. There were times when I cried, but I can now look back on them fondly.

The most impressive styling skill I learned from her was the styling of glamorous women. No matter how unique the character, she always uses a belt to create a waist shape. Since she prefers heels, everyone she dresses appears to have good posture. At the same time, she constantly breaks the rules, such as crossing suspenders in the front. A corset belt over a simple dress, leather fingerless gloves, and in the end, it always settles into "Patricia Field styling." In reality, she would redo it many times and never give up until she was satisfied. And the moment it was decided, she would say, "I love it! What do you think? Well, I don't know anymore." and then go off to smoke a cigarette.

Patricia Field has achieved great success in various projects over time, which cannot be discussed without acknowledging the passionate Patricia Family that has worked with her. She has always attracted,

Karlo at Hair Salon, c. 2003

discovered, helped, spent time with, and enjoyed the company of characters with sharp insight, honesty, clumsiness, high pride, a love for fashion, and a wicked yet adorable personality.

Patricia is always open and curious, never rejecting anything that comes her way, and constantly transforming everything into her own energy. It's immeasurable how much she has contributed to the art, fashion, and entertainment industries, from the unknown to the famous.

Many Japanese people have also been fascinated and influenced by the World of Patricia. It should be noted that behind the curtain, there were many talented and unique Japanese people supporting her vision.

Patricia's motto is a mix of high-end and affordable, sometimes cheap, fashion that is accessible to young people. She promoted unique one-of-a-kind items and collections from unknown designers without pandering to the mainstream media. She is the only stylist who is not influenced by *Vogue* or *Harper's Bazaar*. When styling a TV show, she combined a $20 pair of Payless shoes[3] with a $5000 Chanel jacket because she thought it fit the scene. And from New York, she became a one-of-a-kind presence in the world. She may be a downtown Lady Liberty who wears the mask of a stylist.

If Patricia Field and her boutique did not exist, New York might have been a world of cloudy skies without the sun.

Patricia Kids

Many talents have emerged from the House of Field, but personally, it is important to mention the ongoing contributions of Paolo and Tobell.

Paolo Nieddu

My former roommate and stylist Paolo Nieddu, who has since become quite famous, started working as a salesperson at Hotel Venus when he was 25, having just moved to New York from Detroit, Michigan. After working as one of the assistant members on the TV series *Ugly Betty* that Patricia was involved with, he went independent. He has been nominated for various costume categories and recently co-designed the costumes for the movie *The United States vs. Billie Holiday* with Prada. He is one of the assistants Patricia is most proud of.

What he learned from Patricia was creating bold combinations of prints and colors, such as mixing stripes with polka dots and layering plaids of different sizes and colors. And no matter how late he danced at parties, he would always come to the studio at 6 a.m. the next morning and work. He asserted that if uptown was represented by *Vogue*'s Diana Vreeland[4], downtown was represented by Patricia Field.

When he visited Japan for the first time, he saw a shop called Boutique Takenoko[5] on Takeshita Street in Harajuku and was reminded of his time working at Hotel Venus in Soho. He also said that he understood why Patricia loved Japan and sold so many Japanese items in her boutique.

Tobell Von Cartier

Another person worth mentioning is New York drag legend Tobell Von Cartier. She worked as a wig master at both Patricia Field and Hotel Venus hair salon during the day while performing as a drag queen at the famous New York drag queen cabaret, Lucky Cheng's at night. When she showcased her unique glittering, stiff wigs at the fashion show of her friends, the designer duo The Blonds, Patricia, who was watching from the front row immediately requested that Tobell make the wigs for sale at the store. Needless to say, many hair stylists and celebrities subsequently sought out these wigs.

Tobell is now thriving with her own apparel brand, Steven Davis, which is, of course, also available at Patricia's gallery *ARTFashion*.

Footnotes:

1. Founded in 1996 by charismatic owner Masuko Kato, Ash & Diamonds is the original sexy, sparkly girls' fashion brand.

2. A luxury shoe brand from the UK, established in 1972 by a Spanish designer of the same name.

3. Founded in 1956, Payless was once the number one large-scale discount chain store in the United States, offering deals like "buy one pair, get the second half price." The stores closed in 2019.

4. Born in Paris, France, she was an editor for American fashion magazines *Harper's Bazaar* and editor-in-chief of American *Vogue*.

5. A women's clothing store located on Harajuku's Takeshita Street opened in 1979. It started with custom-made costumes for cabarets and discos in the 80s. Young people wearing Takenoko's outfits while dancing was called "Takenoko-zoku," which became a huge trend. Lady Gaga, Ayumi Hamasaki, K-POP group stylists, and others have visited the store. Now in its 44th year of business, it is a one-of-a-kind famous store, still in full operation, creating custom stage costumes for underground idols and more.

VAH! **GIRRRL!** PATRICIA FIELD.COM

PAT'S FAVORITA
SALES REPAIRS & PARTS. SE HABLA ESPANOL
Patricia Field

VOGUE

TO 306 BOWERY →

教えてパトリシ

So money doesn't buy you style?
Style is not dependent upon dollars.
Style is dependent upon creativity
and the ability to express your
attitude in the way that you dress.

Patricia Field

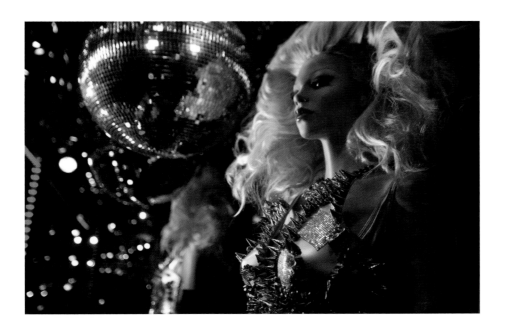

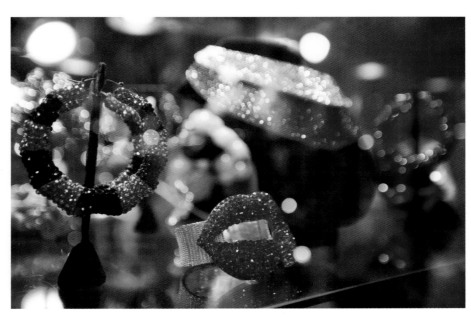

HOUSE OF Field

Chapter 2:

**PATRICIA FIELD
ART COLLECTION**
パトリシア・フィールド・アートコレクション

ARTISTS│アーティスト

RICHARD ALVAREZ

The House of Field
Artist File #1

リチャード・アルバレス

ニューヨーク、ブロンクス生まれ
ニューヨークとマイアミ在住

1970年代のブロンクスで幼少期を過ごしたアルバレスは、10代でダウンタウンに移り、アート、ファッション、ナイトライフのシーンで活躍してきた。パトリシア・フィールドとの仕事を通じファッションスタイリストとしてキャリアをスタートし、ジャン＝ミシェル・バスキア、キース・ヘリング、マドンナらと交流を持つことで、次第にアーティストとして活動の幅を広げていく。ガラスを支持体とし、グリッターを用いながら自らが考案したレイヤー構造を巧みに取り入れた彼の作品には、幼少期に彼を取り囲んでいたキューバの民族信仰であるサンテリアやカトリックなどの宗教的な図像が引用されている。ルネサンス絵画、80年代マンハッタン・アンダーグラウンドの境域、ラテン文化特有の美学といった要素が絡み合い、神秘的で魅惑的な画面を構成する。1960年代以降、商業空間や家具のデザイン分野に革新をもたらしたデザイナー、倉俣史朗（1934−1991）からも影響を受けており、バワリー通り306番地の「パトリシア・フィールド」がブティックになる以前にフィールドが暮らしていたスペースにおいて、《レス＝ビヨンド》（pp. 48−50）はキッチン棚の一部であった。

Born in the Bronx, New York
Resides in New York and Miami

Having spent his childhood in the Bronx during the 1970s, Alvarez moved downtown as a teenager and became active in the art, fashion, and nightlife scenes. He began his career as a fashion stylist through his work with Patricia Field, and as he interacted with Jean-Michel Basquiat, Keith Haring, and Madonna, he gradually expanded his activities as an artist.

In his works, which skillfully incorporate a layered structure he devised himself using glass as a support medium and glitter, Alvarez quotes religious imagery from Santeria and Catholicism, the Cuban folk religions that surrounded him in his childhood. Elements such as Renaissance painting, the boundary of 1980s Manhattan underground, and the unique aesthetics of Latin culture intertwine, creating a mysterious and enchanting picture. He was also influenced by designer Shiro Kuramata (1934-1991), who brought innovation to commercial spaces and furniture design in the 1960s. Before Patricia Field's boutique at 306 Bowery, *Less-Beyond* (pp. 48-50) was part of the kitchen shelf in the space where Field used to live.

47

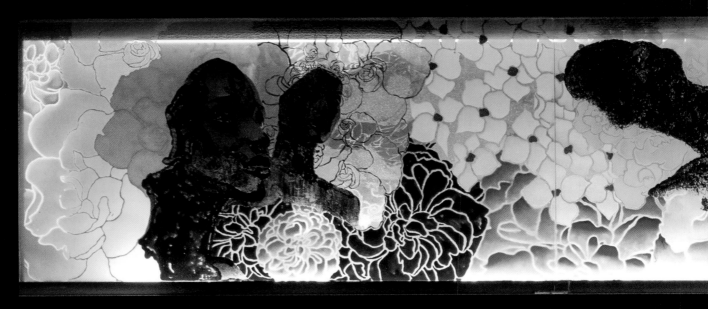

1.
レス＝ビヨンド
Less - Beyond
2008

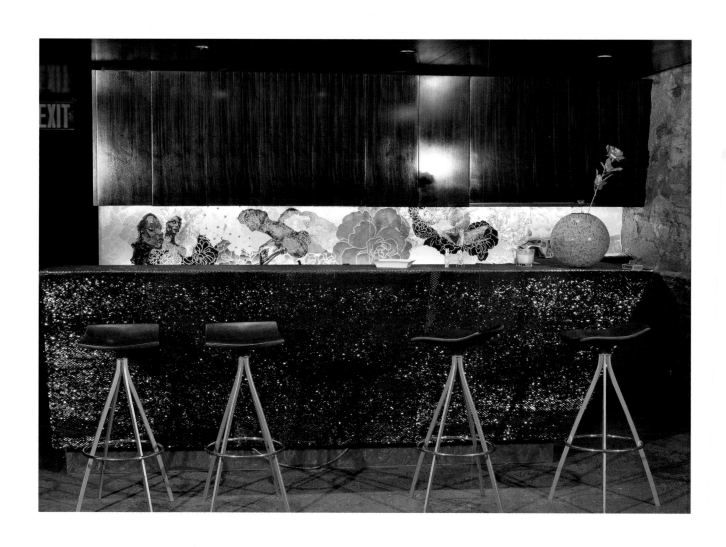

2.
無題
Untitled
2001

3.
無題
Untitled
2005

JOJO AMERICO

ジョジョ・アメリコ

The House of Field
Artist File #2

1963年ニューヨーク、ヨンカーズ生まれ
ニューヨーク、ブロンクス在住

裁縫業に従事する母親の影響により幼少期からファッションに強い関心を抱き、10代でジュエリーの制作を始める。チャック・クロースやアンディ・ウォーホル、デイヴィッド・ホックニー、キース・ヘリングに影響を受けていた。ブティック「パトリシア・フィールド」では、約20年にわたりビジュアルディレクターとしてウィンドウデザインからディスプレイ、ファッションコーディネートまで運営全体に関わる。

アメリコの絵画には、映画からインスパイアされたモチーフがしばしば登場し、《レッド・デビル》(p. 56)、《キャット・ウーマン》(p. 57)もその例である。彼の芸術表現は絵画に留まらず、ファッションデザイン、ヘアスタイリング、パフォーマンスと多岐にわたる。1998年にはポール・アレキサンダー、ナショーム・ウッデンとともに、エレクトロニックダンスミュージックバンド「ザ・ワンズ」を結成。現在はDJとして活動する傍ら、ファッションデザイナー、ヘアスタイリストとしても活躍している。

Born in Yonkers, New York, in 1963
Resides in the Bronx

Americo graduated from the Graphic Design department at Pratt Institute in 1984. He developed a strong interest in fashion from an early age, influenced by his mother, who worked in the sewing industry, and began creating jewelry in his teens. He was influenced by artists such as Chuck Close, Andy Warhol, David Hockney, and Keith Haring. At *Patricia Field*, he was involved in the overall operation of the boutique for about 20 years as a visual director, handling everything from window design to display and fashion coordination.

In Americo's paintings, motifs inspired by horror movies often appear, as seen in *Red Devil* (p. 56) and *Cat Woman* (p. 57). Americo's artistic expressions extend beyond painting to fashion design, hairstyling, and performance. He is currently active as a DJ while also working as a fashion designer and hairstylist. Notably, since 1998, he has been a member of the electronic dance music band "The Ones" with Paul Alexander and the late Nashom Wooden.

Self Portrait, Jojo Americo

4.
レッド・デビル
Red Devil
1998

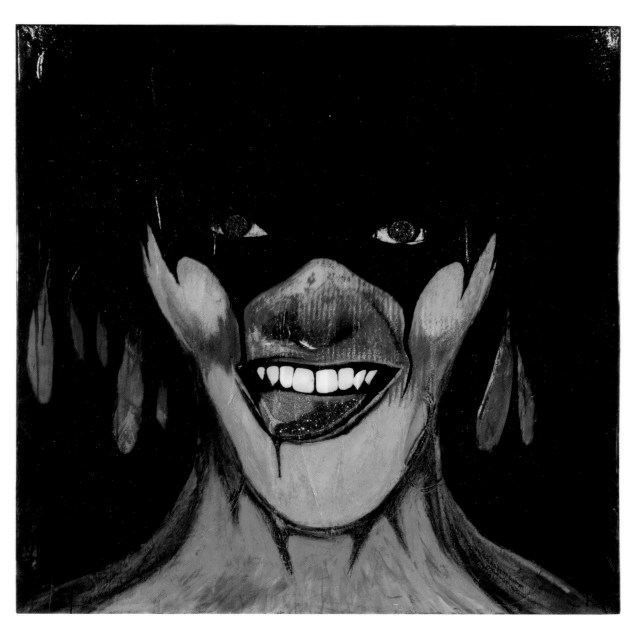

5.
キャット・ウーマン
Cat Woman
2009

STEVEN BROADWAY
スティーブン・ブロードウェイ

The House of Field
Artist File #3

1965年ネパール生まれ
ニューヨーク在住

幼少期から絵画、彫刻、陶芸などに触れていたブロードウェイは、10代初め
にニューヨークでアートを学ぶことを決意し、1983年にパーソンズ・スクー
ル・オブ・デザインに入学。1960年代以降にファッション・イラストレーター
として活躍したアントニオ・ロペスに影響を受ける。フォトグラファー、キュ
レーター、アートディレクターなど多彩なアーティストとして幅広い分野で活
躍する傍ら、1988年から自身の母校でもあるパーソンズ・スクール・オブ・
デザイン、またファッション工科大学と両校のファッション・イラストレーショ
ン部門で教鞭を執ってきた。
パーソンズ在学中に立ち寄ったブティック「パトリシア・フィールド」で
フィールドと出会い、ポートフォリオのカートゥーン調のキャラクターが気に
入られたことで、店内の壁や窓、フィッティングルームのドアなどに絵画制
作を依頼される。ドアに大きく描かれた男性の顔はハウス・オブ・フィール
ドを代表するデザイナー、デイビッド・ダルリンプルの顔である。「試着室
のドアに描かれたハイヒール」(p. 60)はブロードウェイにとってドラァグク
イーンの女性らしさを最大限に象徴するもので、彼のアートには祖国では
出会うことのなかったニューヨーク特有の多種多様な人種と文化が描き
込まれている。

Born in Nepal in 1965
Resides in New York

Broadway studied painting, sculpture, and pottery from an early age. In
his early teens, he decided to study art in New York and enrolled in
Parsons School of Design in 1983. He was influenced by Antonio Lopez,
a fashion illustrator who was active from the 1960s onwards. In addition
to working in various fields as a versatile artist, including photographer,
curator, and art director, he has taught in the fashion illustration
department at both Parsons School of Design, his alma mater, and the
Fashion Institute of Technology since 1988.
During his time at Parsons, he met Patricia Field when he visited her
boutique, Patricia Field. Field liked the cartoon-style characters in his
portfolio, and he was commissioned to create artwork for the boutique's
walls, windows, and fitting room doors. The large male face painted on
the door is David Dalrymple, a designer who represents the House of
Field. Broadway says that High Heel on Dressing Room Door (p. 60)
epitomizes the femininity of drag queens to the fullest. His art incorpo-
rates the diversity and cultures unique to New York, which he could not
encounter in his homeland.

59

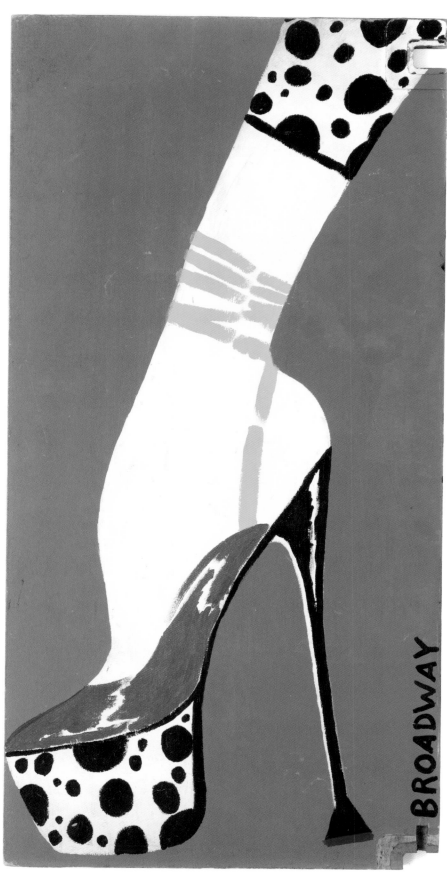

6.
試着室のドアに描かれたハイヒール
High Heel on Dressing Room Door
1990

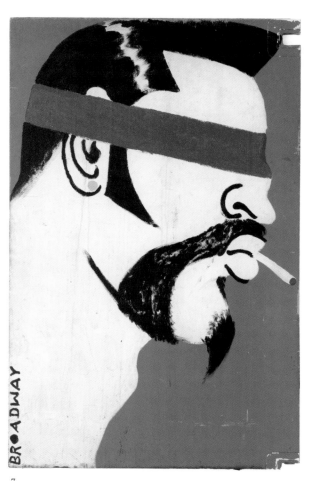

7.
試着室のドアに描かれたポートレート
Portrait on Dressing Room Door
1990

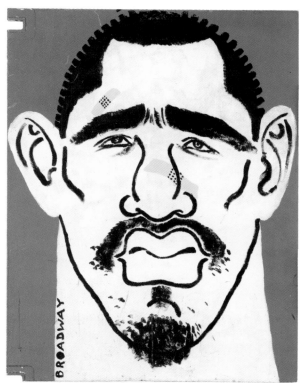

8.
試着室のドアに描かれたポートレート
Portrait on Dressing Room Door
1990

PAUL CHELSTAD

ポール・チェルスタッド

The House of Field
Artist File #4

1948年アイオワ、スーシティ生まれ
同地在住

1966年にウェイン州立大学で美術を学び、1967年にルイジアナ州立サウスウェスタン大学に編入。1968年から1975年までニューオーリンズに住み、1980年にニューヨークに居を構えた。1982年春、ニューヨークのアーティストたちにステンシルアートを広める活動をしていたアレックス・ヴァラウリに紹介され、公共の壁にステンシルを施すようになる。1994年、チェルスタッドは故郷であるスーシティに戻り、この地で大規模な委託壁画を手がけたことによって広く知られるようになった。2022年にはスーシティ公立博物館に「ブラック・ライブズ・マター」を掲げた作品が収蔵された。

Born in Sioux City, Iowa in 1948
Resides in Sioux City, Iowa

Chelstad began studying art at Wayne State University in 1966 and transferred to Louisiana State University Southwestern in 1967. He lived in New Orleans from 1968 to 1975 and moved to New York in 1980. In the spring of 1982, Chelstad was introduced to Alex Vallauri, who was promoting stencil art among New York artists, and began applying stencils to public walls. He returned to his hometown of Sioux City in 1994 and gained recognition for his large-scale commissioned murals in the area. In 2022, the Sioux City Public Museum added his artwork featuring Black Lives Matter to its collection.

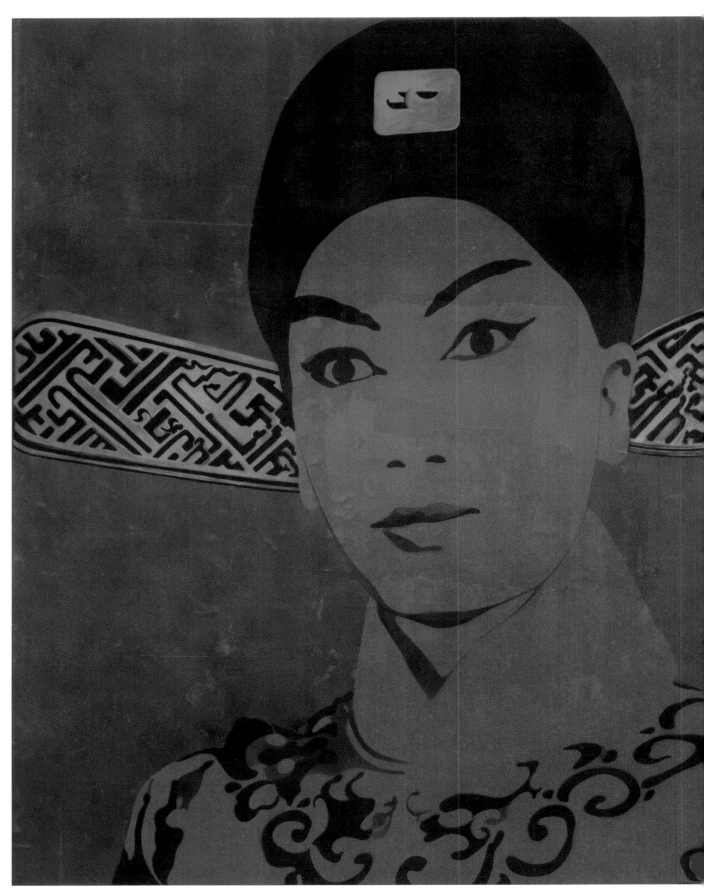

9.
シー・ペイ・プー
Shi Pei Pu
1987

10.
アメリカンフットボール・ビクトリー
American Football Victory
1988

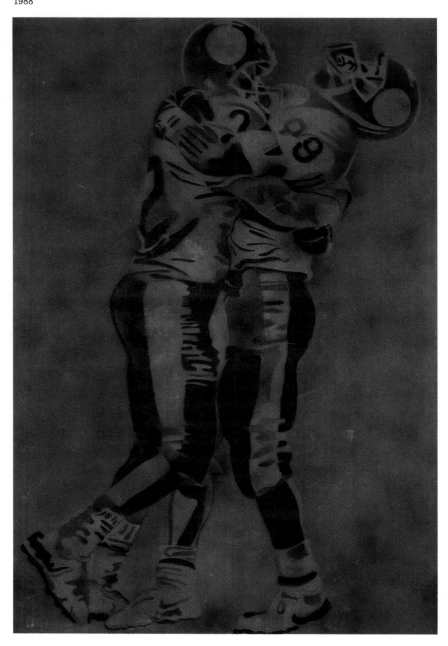

11.
キース・H
Keith H.
1990

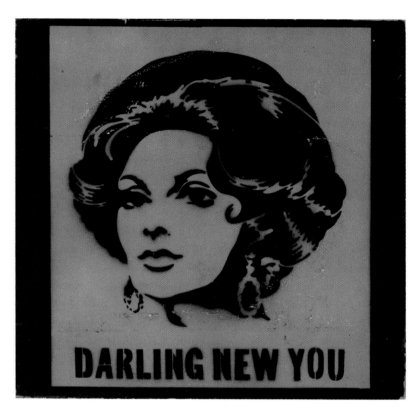

12.
素敵な新しいあなた
Darling New You
1989

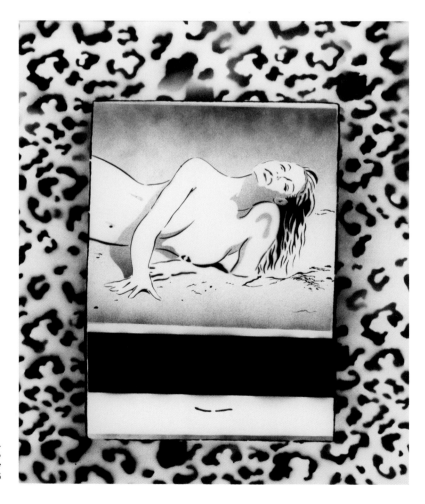

13.
擦る前にカバーを閉じる
Close Cover before Striking
1986

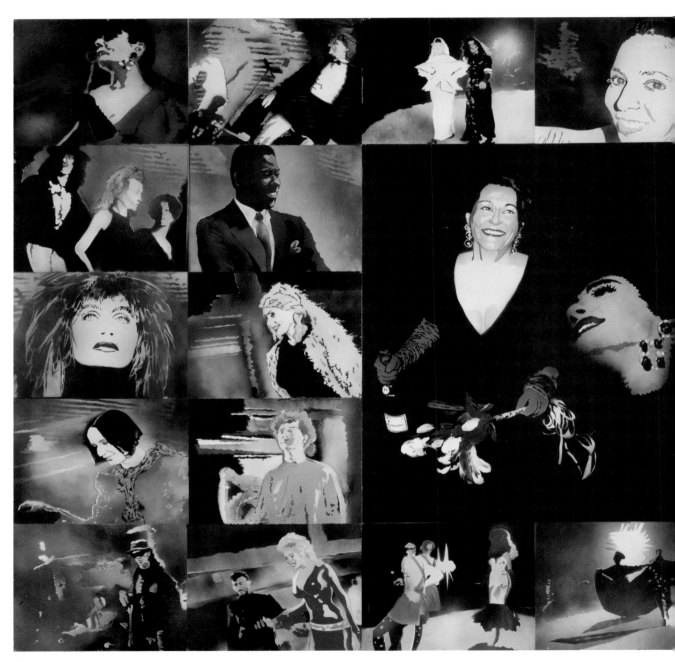

14.
1988年に行われたパット・フィールドのファッションショーのための壁画
Mural for Pat Field's fashion show in 1988
1988

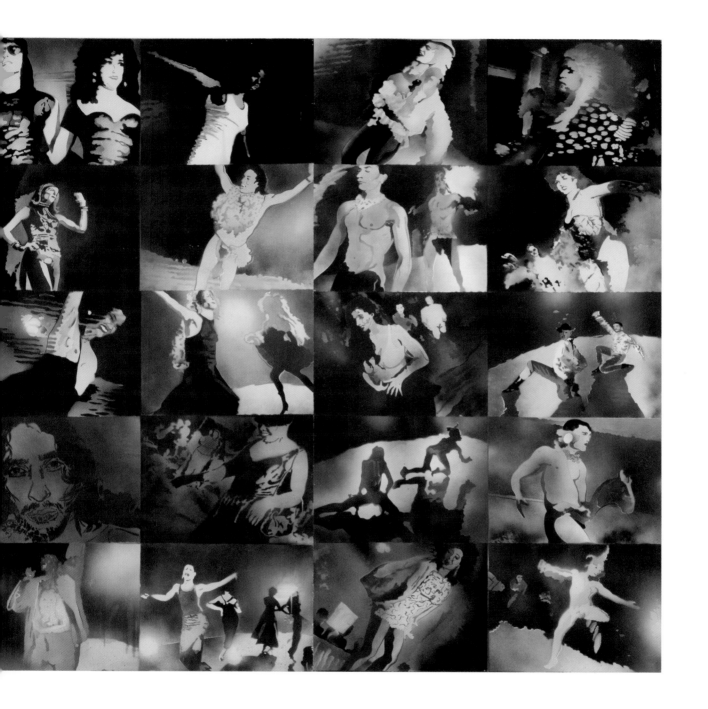

CRAIG COLEMAN

クレイグ・コールマン

1961年カリフォルニア、サンノゼ生まれ
1994年フロリダ、マイアミビーチにて没

1980年代ニューヨークのダウンタウン・アートシーンで活躍したコールマンは、人体をインスピレーション源とする「生」で純朴な表現の彫刻や絵画作品で知られる。1979年、カリフォルニア州サンノゼ高校卒業を機に本格的な作品制作を開始。1981年にニューヨークへ移り、ロウアーイーストサイド12丁目でイギリス人アーティスト、ポール・ベニーとスタジオを共有する。1983年、イーストビレッジの草分け的存在のギャラリーの一つであったニュー・マス・ギャラリーで初個展を開催した。
ストリートで集めた素材を用いて制作されるコールマンの作品には、民族的、宗教的なモチーフが多く、シンプルでありながら深い精神性を湛えている。1989年にはナイトクラブのプロモーターに誘われ、新しいクラブの立ち上げのためマイアミビーチに来たものの契約が破断、しかし同地に残り生活のために彫刻や絵画作品の展示と販売を始める。また「VARLA(ヴァーラ)」名義でパフォーマンス活動も始め、マイアミビーチのドラァグパフォーマーとしてカルト的な人気を博した。1989年にはパトリシア・フィールドのファッションショーにも参加。晩年にはアクティビストとしても活動し、HIV・エイズによる合併症により33歳で死去。膨大な作品を遺し、マイアミ現代美術館、ノースマイアミ現代美術館などに収蔵されている。

Born in San Jose, California in 1961
Died in Miami Beach, Florida in 1994

Known as *VARLA*, Craig Coleman was an artist active in the 1980s downtown New York art scene. He was known for his raw and unpretentious sculptures and paintings, taking inspiration from the human body. After graduating from high school in San Jose, California in 1979, he began producing works full-time. In 1981, he moved to New York and shared a studio with British artist Paul Benney on 12th Street in the Lower East Side. He held his first solo exhibition in 1983 at the New Math Gallery, one of the pioneering galleries in the East Village. Coleman's works, made using materials he collected from the streets, often featured ethnic and religious motifs, embodying a simple yet profound spirituality. In 1989, he was invited to Miami Beach by a nightclub promoter to launch a new club, but the contract fell through. He stayed in the area, starting to exhibit and sell his sculptures and paintings. He also began performing as *VARLA*, gaining cult popularity as a drag performer in Miami Beach. He participated in Patricia Field's fashion show as Varla. In his later years, he became active as an activist and passed away at the age of 33 due to complications from HIV/AIDS. His extensive body of work is now included in private collections and institutions such as the Miami Museum of Contemporary Art and the North Miami Museum of Contemporary Art.

71

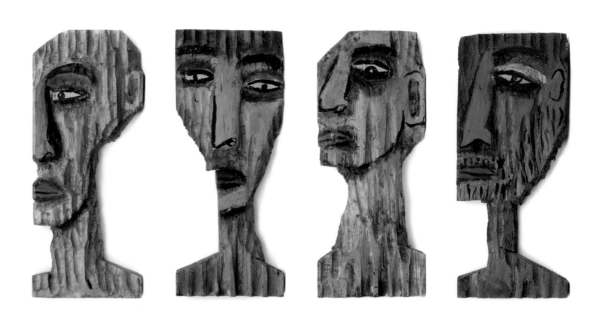

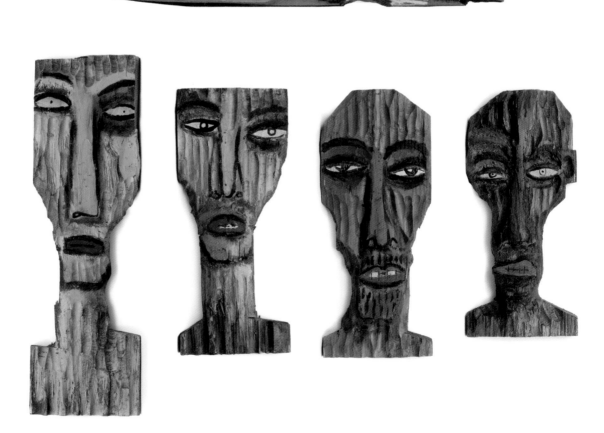

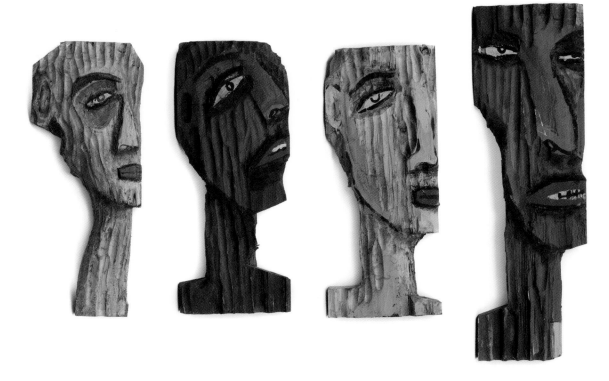

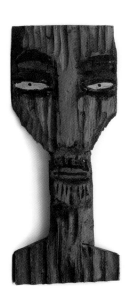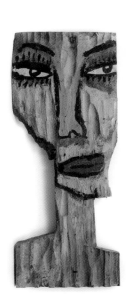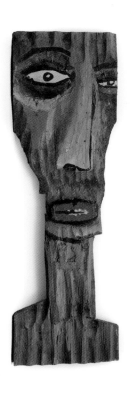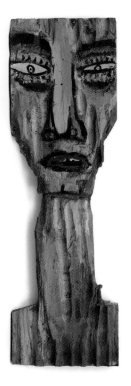

15–31.
無題
Untitled
1994

SCOOTER LAFORGE

スクーター・ラフォージ

The House of Field
Artist File #6

1971年ニューメキシコ、ラスクルーセス生まれ
ニューヨーク在住

アリゾナ大学で美術学士号を取得しサンフランシスコでキャリアを築いたラフォージは、2001年にニューヨークへ移住し、フェローシップを獲得してクーパー・ユニオンに入学。
ラフォージは多様な文脈から取り出した要素をつなぎ合わせ、絵画、彫刻、インスタレーションといった手法で夢と現実の狭間のような世界を生み出す。それらの要素とは、例えば神話や童話であり、ポップカルチャーであり、酒やドラッグ、セックスといった人間の欲望渦巻くイーストビレッジの空気であり、動物愛護や環境問題などの社会問題である。近年では、新型コロナウイルス感染症パンデミックによる隔離期間に、自宅を洞窟に見立て壁中を絵画で覆い尽くす「コロナ・ケイブ・ペインティング」を行い、その様子をウェブサイトで公開している。ブティック「パトリシア・フィールド」ではデザイナーとして活躍し、現在でも「パトリシア・フィールド・アートファッション」で衣類を支持体とした作品を発表し続けている。
ラフォージの作品は、LGBTQIA+の芸術作品を紹介するレスリー・ローマン美術館(ニューヨーク)などに収蔵されている。

Born in 1971 in Las Cruces, New Mexico
Resides in New York

LaForge, who earned a Bachelor of Fine Arts degree at the University of Arizona and built his career in San Francisco, moved to New York in 2001 and enrolled at Cooper Union after receiving a fellowship. LaForge creates a world that lies between dreams and reality by connecting elements taken from various contexts, using techniques such as painting, sculpture, and installation. These elements include myths and fairy tales, pop culture, the desire-fueled atmosphere of the East Village revolving around alcohol, drugs, and sex, and social issues such as animal welfare and environmental problems. In recent years, during the isolation period due to the COVID-19 pandemic, LaForge has been creating Corona Cave Paintings, covering the walls of his home, turned into a cave-like space, with paintings and sharing the process on his website.

At the boutique Patricia Field, LaForge has been active as a designer, and he continues to present works using clothing as a support medium at Patricia Field ARTFashion to this day. LaForge's works are included in collections such as the Leslie-Lohman Museum (New York), which features LGBTQIA+ art.

32.
パトリシア・フィールドのポートレート
Portrait of Patricia Field
2014

MARTINE

マーティーン

The House of Field
Artist File #7

マーティーンの生み出すパワフルなドラァグクイーンや女性たちは、1990年代以降、パトリシア・フィールドのビジュアル・アイコンとして君臨している。幼少期にアートに目覚めた彼の最大のインスピレーションは、アメリカのランジェリーブランド「フレデリックス・オブ・ハリウッド」のカタログだった。イラストを描くことに魅了され大学で専門的に美術を学ぶも、伝統的な美術教育とは常に対立を感じていた。

自身のスタイルを貫いたマーティーンは23歳でパトリシア・フィールドとの仕事をはじめ、世界各地のショップやクラブに壁画を制作。日本では1990年代に港区芝浦に存在した巨大クラブ「GOLD」でライブペインティングを行う。コカ・コーラ、MCM、メイベリン ニューヨークなど企業とのコラボレーションを実現させ、2016年には世界最大のドラァグクイーンの祭典「ル・ポールのドラァグコン」の公式Tシャツに起用された。

Martine's powerful drag queens and women have reigned as visual icons for Patricia Field since the 1990s. His biggest inspiration as a child interested in art was the catalog of the American lingerie brand, Frederick's of Hollywood. While he was fascinated by drawing illustrations and studied art professionally in college, he always felt a conflict with traditional art education. Remaining true to his own style, Martine began working with Patricia Field at the age of 23, creating murals for shops and clubs around the world. In Japan, he performed live painting at the mega club GOLD in Shibaura, Minato-ku in the 1990s.

He has collaborated with companies such as Coca-Cola, MCM, and Maybelline New York, and in 2016, his artwork was featured on the T-shirt for the world's largest drag queen convention, RuPaul's DragCon.

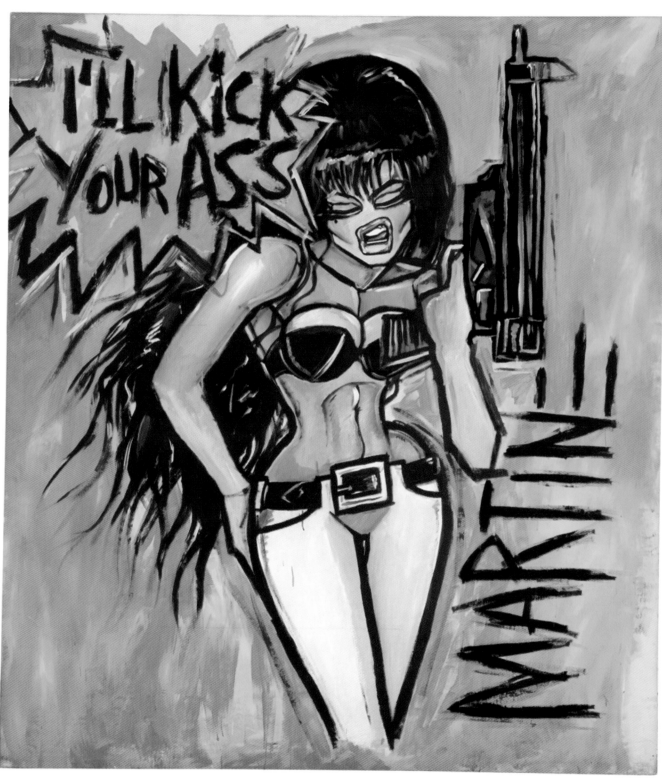

33.
ナメんなよ
I'll Kick Your Ass
N/D

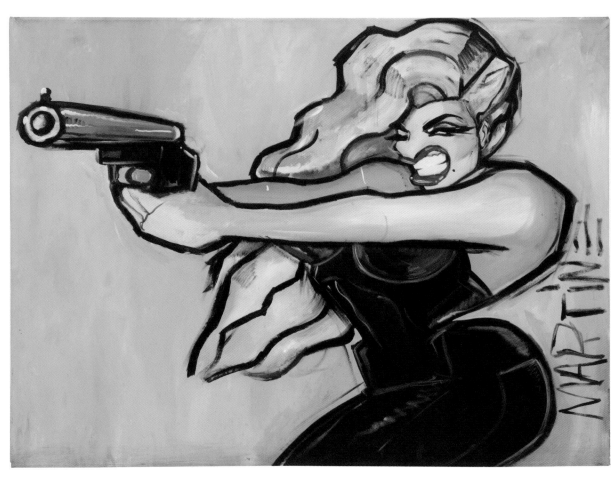

34.
銃を持つガール
Girl with Gun
1995

35.
カット・アウト・ガール
Cut Out Girl
N/D

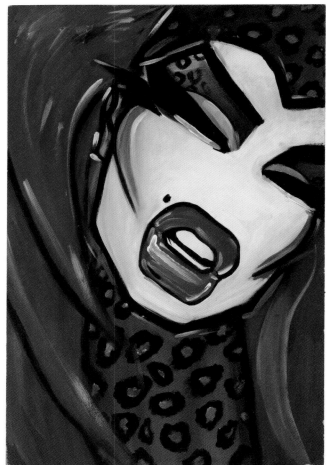

36.
ガール
Girl
N/D

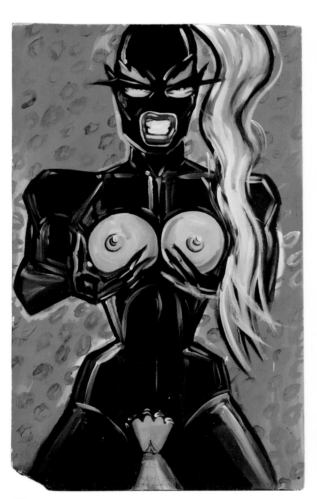

37.
ガール
Girl
N/D

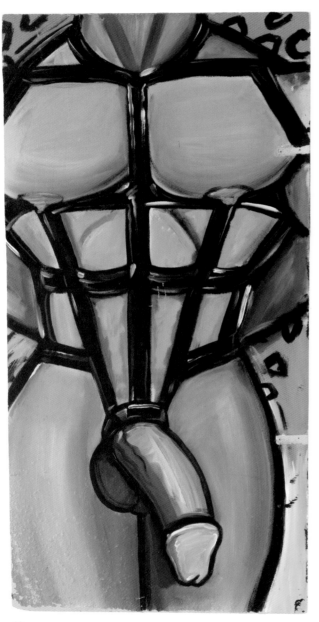

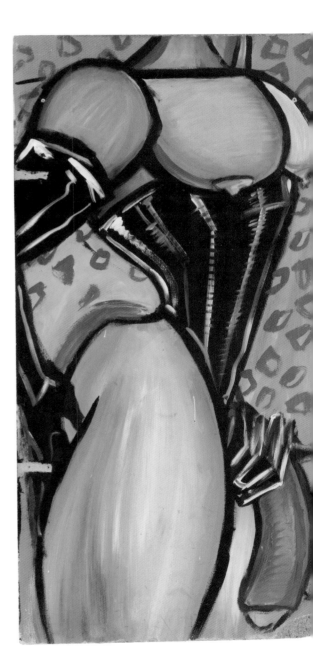

84

38.
ペニス
Penis
N/D

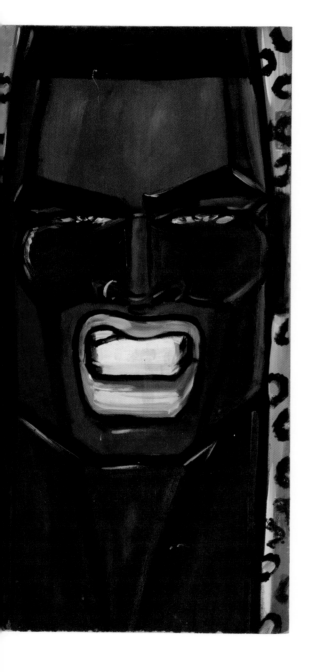

39.
フェイス
Face
N/D

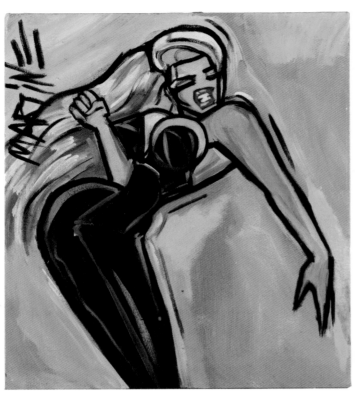

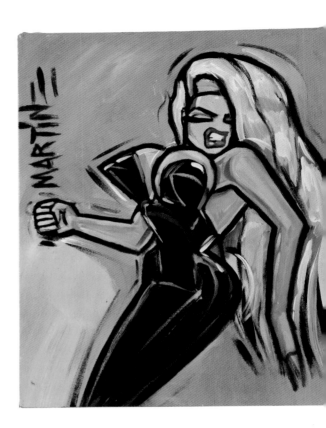

40.
3 ガールズ
3 Girls
N/D

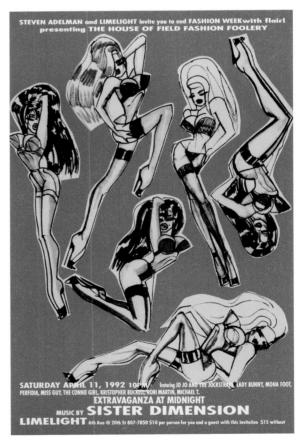

41.
ライムライト・ファッションショーのためのポスター
Poster for Limelight Fashion Show
1992

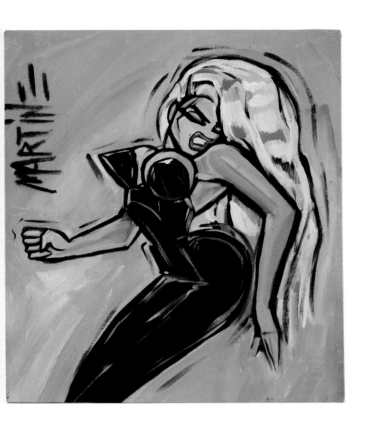

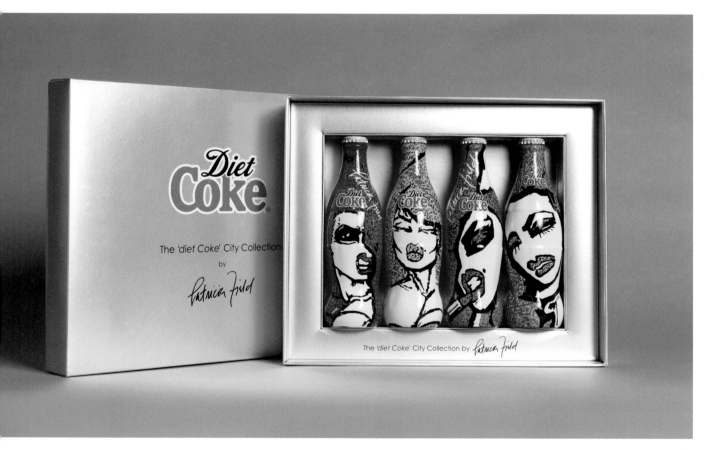

パトリシア・フィールドによるダイエットコーラ・シティ・コレクション
The "Diet Coke" City Collection by Patricia Field
2008

SUZANNE MALLOUK

スザンヌ・マルーク

*The House of Field
Artist File #8*

1960年カナダ、オンタリオ、オレンジビル生まれ
ニューヨーク在住

アラブ人の父とイギリス人の母のもとに生まれたマルークは、オンタリオ州ロンドンにある美術学校のH. B. ビールに通い、アーティストを目指して1980年にニューヨークへ移る。ダウンタウンのアートシーンで活躍しながら、1980年代初頭にアンドレ・ウォーカーやマーク・ジェイコブス、フランチェスコ・クレメンテ、アンディ・ウォーホルらのモデルとして活躍。80年代後半にはシンガー「ルビー・デザイア」としてキャピトル・レコードと契約し、ナイトクラブ「ザ・パラディアム」などでのパフォーマンスやヨーロッパ・ツアーを行う。カナダの白人社会の小さな町でアングロ・アラブとして育ち、自身を異質な存在として感じていたマルークは、イーストビレッジでアーティスト、ミュージシャン、映画製作者、ダンサーらと関わることで初めて自由を感じたという。1981年からジャン=ミシェル・バスキアが亡くなる1988年まで交際関係にあり、《Self Portrait with Suzanne》(1982年)をはじめ、バスキアの作品にはマルークの姿が描かれたものが複数存在する。1980年代半ばに描かれた作品群 (pp. 90–93) は、異人種間の関係にある25歳のバイカルチュラルな女性というアイデンティティの「置き所」をめぐる内なる葛藤を表している。
その後、ハンター・カレッジで心理学の学士号を取得し、2001年に西インド諸島のグレナダにあるセントジョージズ大学医学部を卒業。 2005年、ニューヨークのベス・イスラエル・メディカル・センターで精神科の研修医を修了。現在はニューヨークで精神科医として個人開業する傍ら、「パトリシア・フィールド・アートファッション」にもアーティストとして参加している。

Born in Orangeville, Ontario, Canada in 1960
Resides in New York

Born to an Arab father and a British mother, Mallouk attended H.B. Beal, an art school in London, Ontario, and moved to New York in 1980 to pursue a career as an artist. While active in the downtown art scene, she worked as a model for Andre Walker, Marc Jacobs, Francesco Clemente, and Andy Warhol in the early 1980s. In the late 80s, she signed a contract with Capitol Records as a singer under the name Ruby Desire and performed at venues such as the Palladium and on European tours.

Growing up as an Anglo-Arab in a small, predominantly white Canadian town, Mallouk felt like an outsider. She experienced a sense of freedom for the first time while interacting with artists, musicians, filmmakers, and dancers in the East Village. She was in a relationship with Jean-Michel Basquiat from 1981 until his death in 1988. Her likeness appears in several of Basquiat's works, including *Self Portrait with Suzanne* (1982). The artworks created in the early 1980s (pp. 90–93) represent her internal struggles to navigate her identity as a 25-year-old bicultural woman in an interracial relationship.

Mallouk later earned a bachelor's degree in psychology from Hunter College and graduated from St. George's University School of Medicine in Grenada, West Indies, in 2001. In 2005, she completed her psychiatric residency at Beth Israel Medical Center in New York. Currently, she works as a psychiatrist in private practice in New York, while also participating as an artist in Patricia Field ARTFashion.

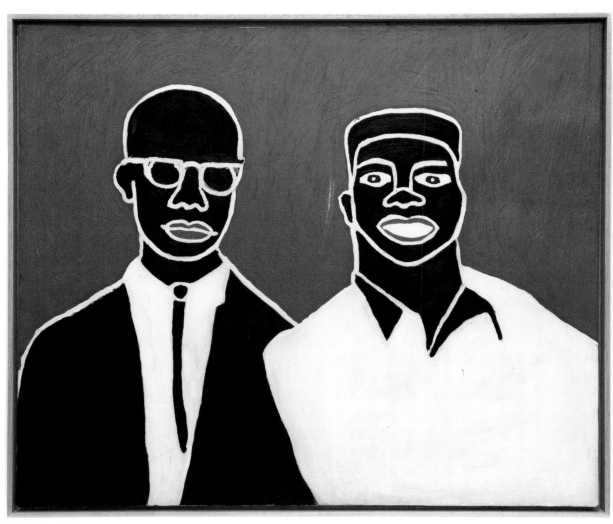

43.
マルコム・エックス、カシアス・クレイ
MALCOM X, CASSIUS CLAY
1984

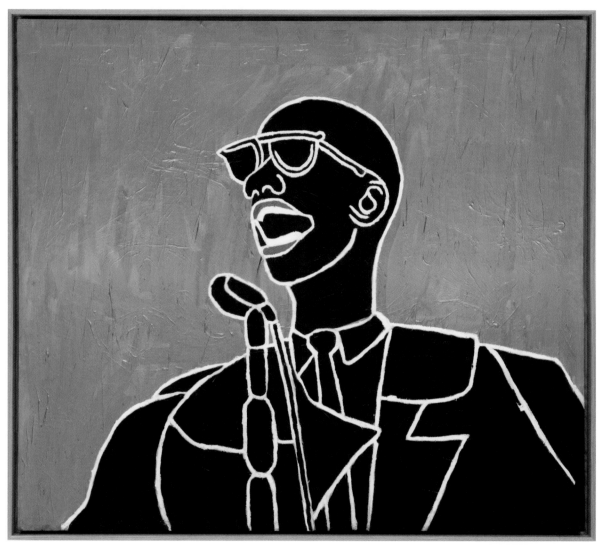

44.
演説家ーマルコム・エックス
ORATOR–MALCOM X
1984

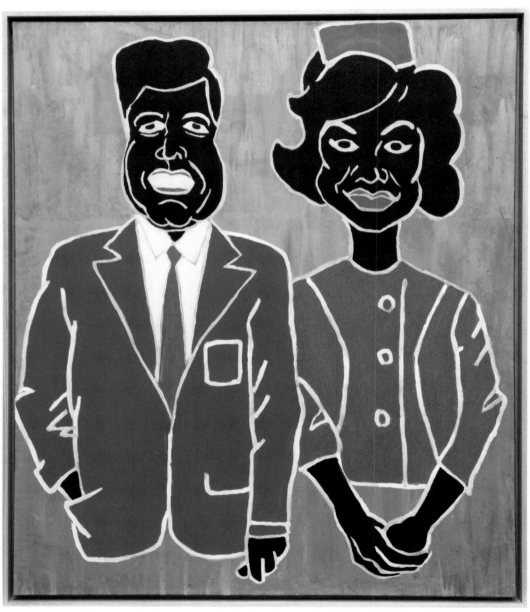

45.
JFK & JO
JFK & JO
1985

46.
これなしでは出かけるな
DON'T LEAVE HOME WITHOUT IT
1985

TINA PAUL

ティナ・ポール

The House of Field
Artist File #9

フロリダ、サーフサイド生まれ
同地在住

「私たちが見るもの、経験するものには美しさがあり、それぞれの瞬間がどうつながるかが重要なのです」と語るポールは、1970年代以降、ニューヨークやマイアミのナイトライフを撮影し続ける写真家で、アーキビスト、歴史家、アクティビストでもある。
アルバムジャケットのアートワークや、新聞や雑誌のデザインが好きだったことから写真に関心を持ち、1980年にニューヨークへ移り、スクール・オブ・ビジュアル・アーツで美術とフォトジャーナリズムを学ぶ。1982年にパトリシア・フィールドと知り合って以降、仕事から私生活に至るまで彼女の活動を記録し続けている。『イーストビレッジ・アイ』や『ディテール・マガジン』などの雑誌にはポールによるフィールドの広告も掲載された。40年以上に及ぶキャリアで蓄えられた写真はいつ、どこで、誰を撮影したのか詳細な記録を残していることでジャーナリズムの精神が表れ、流動的なアンダーグラウンドカルチャーを伝える緻密で膨大なアーカイブとなっている。
また、パートナーでグラフィックデザイナーのアーリーン・Z・アヤリンとともに「フィフィベア」として活動しており、故郷であり現在の拠点でもあるサーフサイドの副町長も務めている。
主な展覧会として、「パトリシア・フィールド・アートファッション」展（2017・2019年、アートバーゼル・マイアミ）、「ビヨンド・ザ・ライムライト」（2015年、ファッション美術館）、「エレクトロニック：クラフトワークからダフトパンクまで」展（2019年、フィルハーモニー・ド・パリ）、「グレース・ビフォア・ジョーンズ」展（2020-2021年、ノッティンガム・コンテンポラリー）などがある。

Born in Surfside, Florida
Resides in Surfside, Florida

Paul, a photographer, archivist, historian, and activist who has been capturing New York and Miami nightlife since the 1970s, believes that "There is beauty in most things we see and experience so it is about how we connect in each moment." Her interest in photography began when she enjoyed album cover artwork and newspaper and magazine designs. In 1980, she moved to New York and studied art and photojournalism at the School of Visual Arts. She met Patricia Field in 1982 and has been documenting Field's life, both professionally and personally, ever since. Paul's advertisements featuring Field appeared in magazines such as *East Village Eye* and *Details Magazine*.
Her journalistic spirit is evident in the detailed records of when, where, and who she photographed throughout her 40-year career, resulting in a vast and intricate archive that conveys the fluid underground culture. In addition, she collaborates with her partner and graphic designer Arhlene Z. Ayalin as *fifibear* and served as the deputy mayor of Surfside, her hometown, and current base.
Notable exhibitions include Patricia Field ARTFashion (2017 & 2019, Art Basel Miami), *Beyond the Limelight* (2015, Museum of Fashion), *Electronic: From Kraftwerk to Daft Punk* (2019, Philharmonie de Paris), and *Grace Before Jones* (2020-2021, Nottingham Contemporary).

47.
ハウス・オブ・フィールドのパーティー招待券に使われたハウス・オブ・フィールドのオリジナル作品
House of Field original artwork for House of Field party invitation
1988

48.
パトリシア・フィールドとレベッカ・ワインバーグのホリデーカード
Patricia Field and Rebecca Weinberg Holiday Card
1991

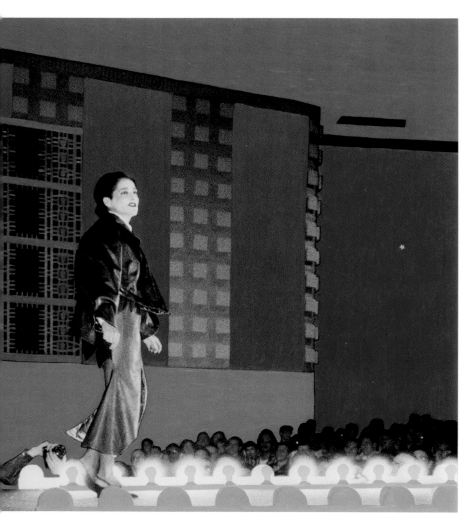

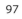

49.
アンドレ・ウォーカーのファッションショーに
登場するパトリシア・フィールド
Patricia Field in Andre Walker Fashion Show
1985

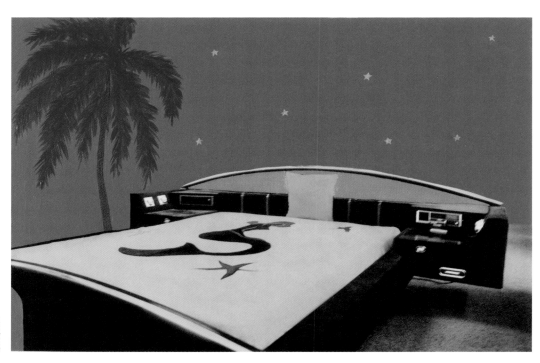

50.
無題
Untitled
1986

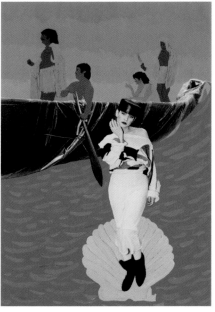

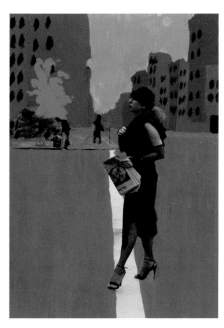

51.
シティコープ・ビルディング、NYC
Citycorp Building, NYC
1985

52.
1984年3月に『イーストビレッジ・アイ』に掲載された
パトリシア・フィールドの広告に登場する
デビー・ジェイコブス
Debbie Jacobs in Patricia FieldAdvertisement,
published in "East Village Eye," March 1984
1984

53.
無題
Untitled
1981

54.
パトリシア・フィールド、東8丁目のロフトにて
Patricia Field at her Loft on East 8th Street
1984

55.
グレース・ジョーンズ、ハランデールのライムライトにて
Grace Jones at Limelight in Hallandale
1978

56.
サウスビーチのパトリシア・フィールドとレベッカ・ワインバーグ
Patricia Field and Rebecca Weinberg in South Beach
1990

57.
サウスビーチのパトリシア・フィールドとレベッカ・ワインバーグ
Patricia Field and Rebecca Weinberg in South Beach
1990

58.
ユニバーシティプレイスのシバとプリプリ
Sheeba and Pri Pri on University Place
1991

59.
メドウランズにてモトクロスに参加するパトリシア・フィールドとバーバラ・デンテ
Patricia Field and Barbara Dente Attending Motorcross at the Meadowlands
1987

SUZAN PITT

スーザン・ピット

The House of Field
Artist File #10

1943年ミズーリ、カンザスシティ生まれ
2019年ニューメキシコ、タオスにて没

リチャード・リンドナー、デイヴィッド・ホックニー、フランシス・ベーコンらに影響を受け、絵画、映像、建築、舞台など多岐にわたる表現に携わる。1960年代末に8ミリカメラを手に入れ、フィルムでのアニメーション制作を始める。1979年、短編アニメーション映画『アスパラガス』がホイットニー美術館にて初公開されて以降、シュールでサイケデリックな作品によってアメリカのインディペンデント・アニメーションにおける作家としての評価を確立した。2017年には、ニューヨーク近代美術館がピットの受賞アニメーション作品の回顧展を開催。また、ドイツで上演された2つのオペラの舞台セットと衣装をデザインしており、このオペラは舞台に初めてアニメーションを取り入れた作品となった。
1988年から1990年代初頭まで、ハーバード大学のカーペンター視覚芸術センターの准教授を務め、1998年からはカリフォルニア芸術大学の実験アニメーション・プログラムで約20年にわたって教鞭を執った。ピットの映像作品はニューヨーク近代美術館をはじめ、世界各地の美術館や映像アーカイブ機関に収蔵されている。

Born in 1943 in Kansas City, Missouri
Died in 2019 in Taos, New Mexico

Influenced by artists such as Richard Lindner, David Hockney, and Francis Bacon, Pitt was involved in a wide range of expressions, including painting, film, architecture, and theater. In the late 1960s, she obtained an 8mm camera and began creating animated films. In 1979, her short animated film *Asparagus* premiered at the Whitney Museum, and she established her reputation as an independent animation artist in the United States with her surreal and psychedelic works. In 2017, the Museum of Modern Art in New York held a retrospective exhibition of Pitt's award-winning animated films. She also designed stage sets and costumes for two operas performed in Germany, which were the first to incorporate animation on stage.

From 1988 to the early 1990s, she served as an associate professor at Harvard University's Carpenter Center for the Visual Arts, and from 1998, she taught for about 20 years in the Experimental Animation Program at the California Institute of the Arts. Pitt's film works are collected in museums and film archive institutions worldwide, including the Museum of Modern Art in New York.

60.
無題
Untitled
N/D

61.
無題
Untitled
N/D

パトリシア・フィールド・アートコレクションの特徴である作家の「多様さ」が指し示すのは、個人を分類する社会的な要素だけではない。4度の移転を行ったブティック「パトリシア・フィールド」としての最後の住所となったバワリー306番地では、作品が回廊型の上階から地下の下階の壁という壁に掛けられ、いたるところの床から壁に重なり合って立て掛けられていた。作品を支えるレンガの壁にはグリッターが塗られ、わずかな照明の光を反射して輝くその粒子は、半世紀にわたり営まれてきた「ハウス」を構成する個々を象徴するかのようであった。
ブティックを彩った多様なアートを総覧することで、フィールドを魅了した個々の作品のエネルギーを感受し、細部に宿る作家性とニューヨークという街での彼らの奮闘を想像されたい。

「アートコレクションは私のこれまでの50年間のキャリアと思い出のすべて。
ハウス・オブ・フィールドの宝もの。」 ── 2016年、パトリシア・フィールド

The "diversity"of artists, which is a characteristic of Patricia Field Art Collection, goes beyond classifying individuals based on social elements alone. At the address of 306 Bowery, which became the final location for the boutique, *Patricia Field* after four relocations, artworks were hung on the walls of the corridor-like upper floor and the basement, leaning against walls and some overlapping on the floor. The brick walls supporting the artworks were adorned with glitter, and the particles shimmered, reflecting the subtle lighting. They seemed to symbolize the individuals who have constituted the "house" that has been active for half a century.
By perusing the diverse art that adorned the boutique, one can feel the energy of the individual works that captivated Field and imagine the artists' creativity embedded in the details and their struggles in the city of New York.

"...the art collection is my memory from 50 years of my career.
They're the treasures of the House of Field." ── Patricia Field, 2016

VARIOUS ART | さまざまなアート

62.
クレイグ・ブランケンホーン
Craig Blankenhorn
セックス・アンド・ザ・シティ（キャリー）
Sex and the City (Carrie)
2004

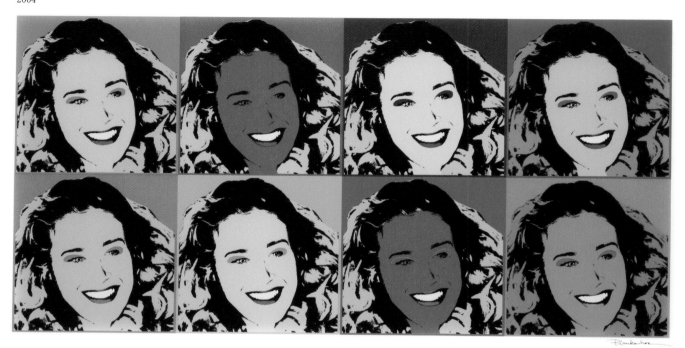

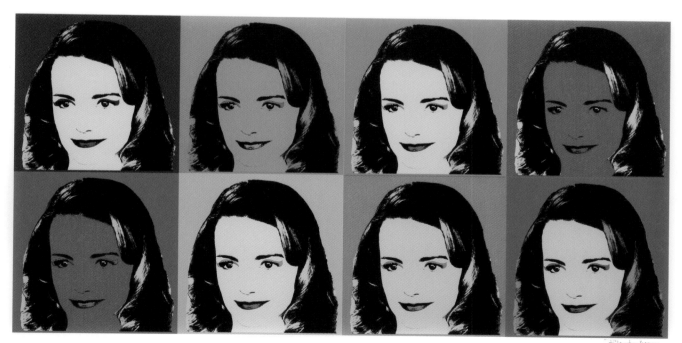

63.
クレイグ・ブランケンホーン
Craig Blankenhorn
セックス・アンド・ザ・シティ（シャーロット）
Sex and the City (Charlotte)
2004

64.
クレイグ・ブランケンホーン
Craig Blankenhorn
セックス・アンド・ザ・シティ（サマンサ）
Sex and the City (Samantha)
2004

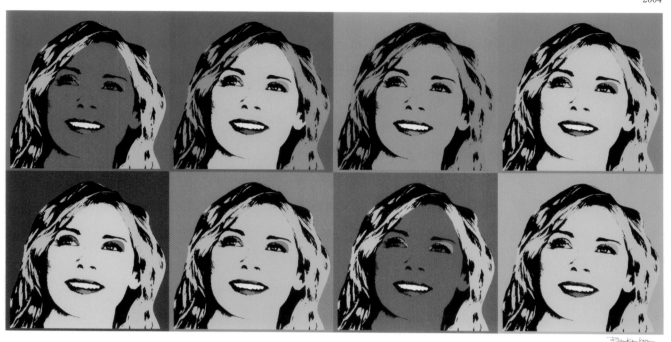

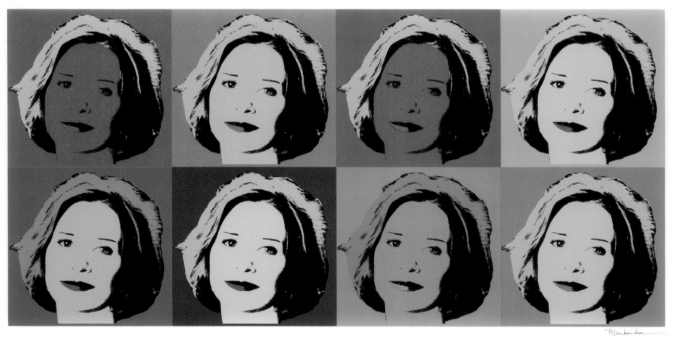

65.
クレイグ・ブランケンホーン
Craig Blankenhorn
セックス・アンド・ザ・シティ（ミランダ）
Sex and the City (Miranda)
2004

66.
アーロン・コベット
Aaron Cobbett
ケリー "ザ・ボディ" キーシャ
Kelly "The Body" Keisha
1989

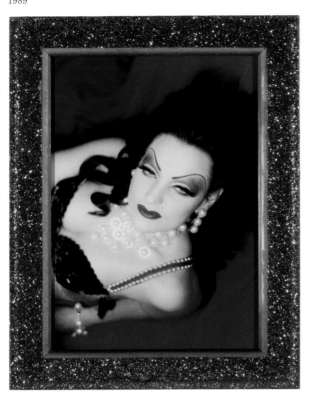

67.
アーロン・コベット
Aaron Cobbett
ロビー・マーティン
Robie Martin
1989

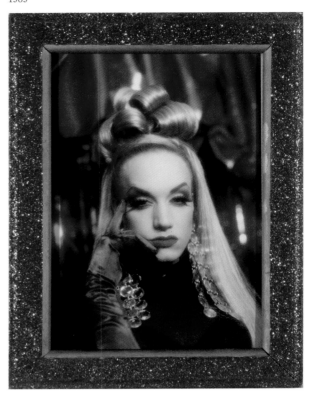

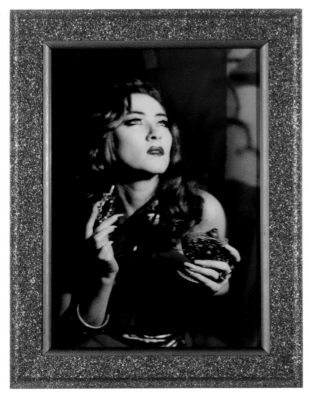

68.
アーロン・コベット
Aaron Cobbett
キモナ117
Kimona 117
1989

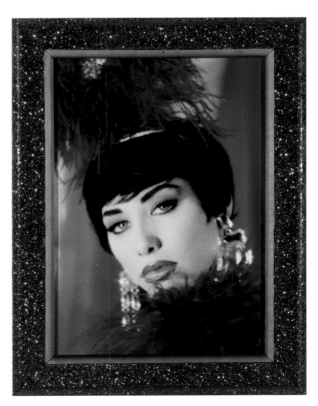

69.
アーロン・コベット
Aaron Cobbett
レベッカ・フィールド
Rebecca Field
1989

71.
アーロン・コベット
Aaron Cobbett
レベッカ・フィールド
Rebecca Field
1989

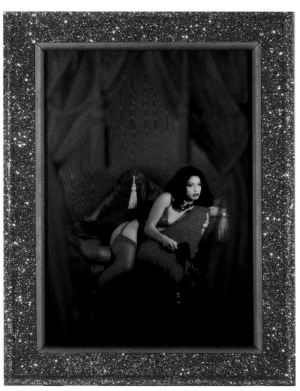

70.
アーロン・コベット
Aaron Cobbett
マリア・アヤラ
Maria Ayala
1989

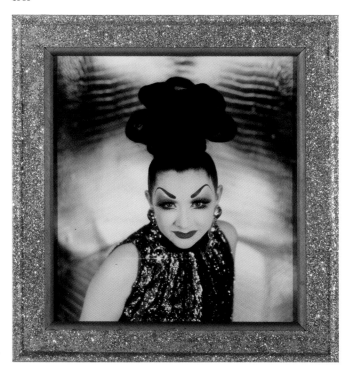

72.
アーロン・コベット
Aaron Cobbett
ザ・ワンズ
The Ones
2004

73.
ジャック・マクヴェイ
Jack McVey
冬の反射　#2（水輪）
Winter Reflection #2 (with rings)
1977

74. (左/Left)
ドナルド
Donald
マンディ
Mandy
1999

75. (右/Right)
ドナルド
Donald
マンディ II
Mandy II
1999

112

76.
アーティ・ハック
Artie Hach
イマジネーションを呼ぶあなたのための鏡
Imagination Calling Mirrors for You
2008

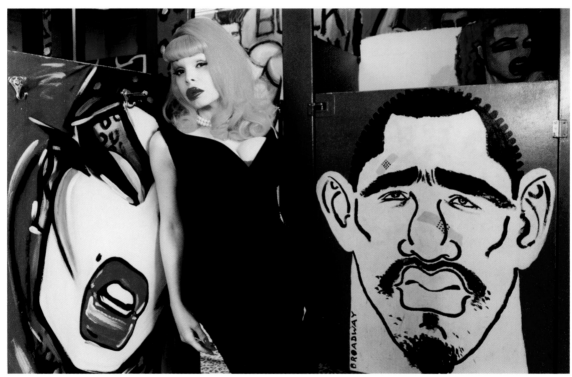

77.
カリン・コールバーグ
Karin Kohlberg
アマンダ・レポア、8丁目店にて
Amanda Lepore at 8th Street Shop
2003

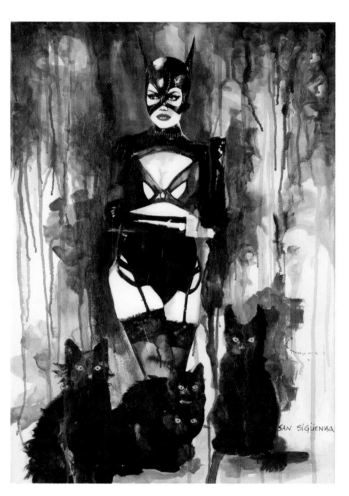

78.
サン・シグエンザ
San Sigüenza
キャット・ウーマン
Cat Woman
2014

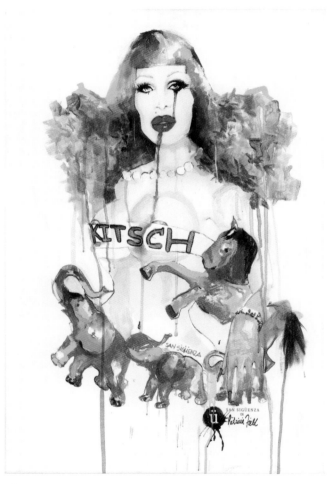

79.
サン・シグエンザ
San Sigüenza
キッチュ
Kitsch
2014

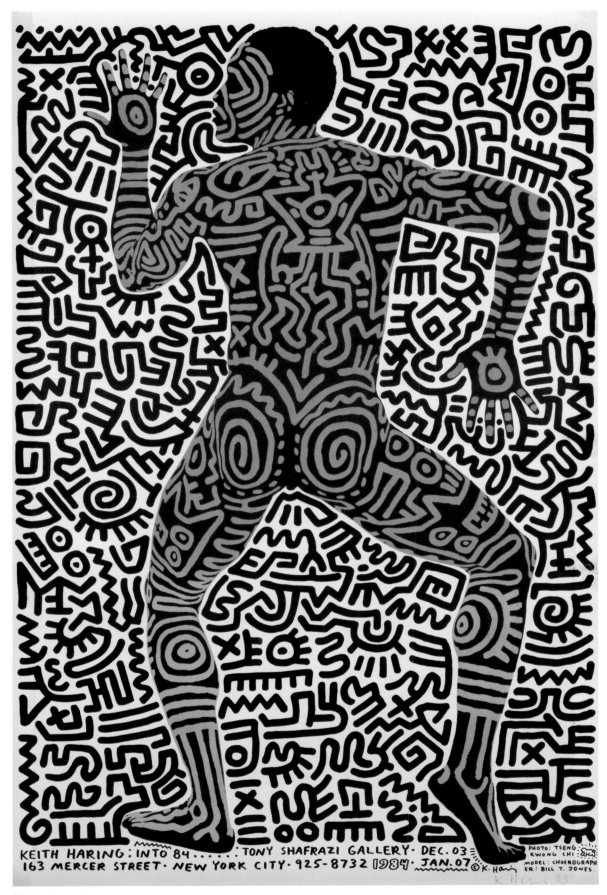

116

80.
キース・ヘリング
Keith Haring
キース・ヘリング: 84年へ…トニー・シャフラジ画廊個展ポスター
Keith Haring: Into 84… at Tony Shafrazi Gallery
1983
Photo by ©Tseng Kwong Chi

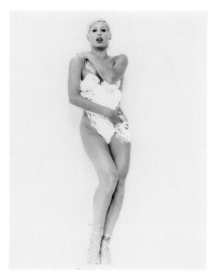

81.
作者不詳
Unknown
無題
Untitled
N/D

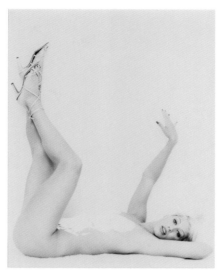

82.
作者不詳
Unknown
無題
Untitled
N/D

83.
作者不詳
Unknown
無題
Untitled
N/D

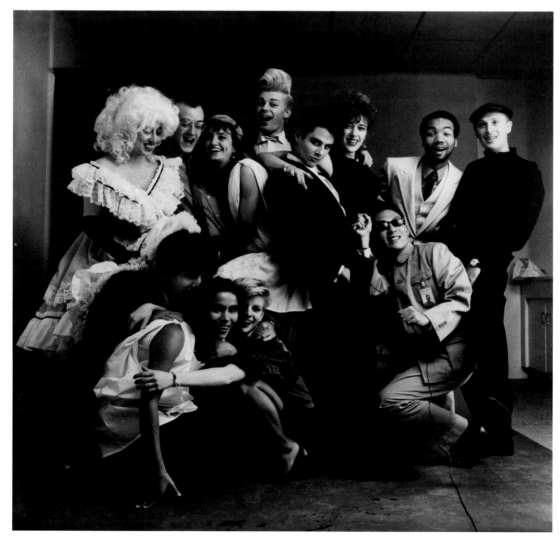

84.
ツェン・クウォン・チ
Tseng Kwong Chi
パック・ボール（全員集合）
Puck Ball (The Gang's All Here)
1983

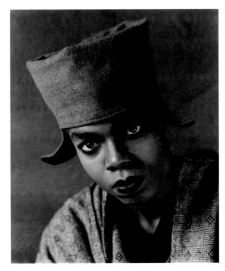

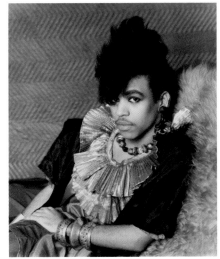

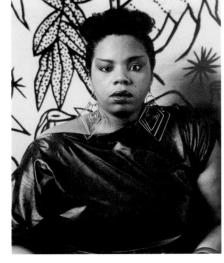

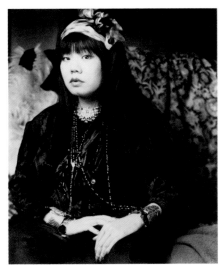

85.
エイドリアン・パナロ
Adrian Panaro
デイビッド
David
1982

86.
エイドリアン・パナロ
Adrian Panaro
ロバート・ルイス
Robert Lewis
1982

87.
エイドリアン・パナロ
Adrian Panaro
ミッチェル
Mitchell
1982

88.
エイドリアン・パナロ
Adrian Panaro
スティーブン
Steven
1982

89.
エイドリアン・パナロ
Adrian Panaro
ジェニファー
Jennifer
1982

90.
エイドリアン・パナロ
Adrian Panaro
アナ・スイ
Anna Sui
1982

91-93.
作者不詳
Unknown
無題
Untitled
N/D

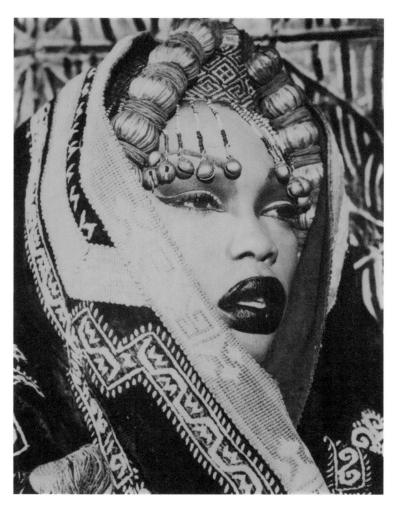

94.
ポール・スタイニッツ
Paul Steinitz
クリスティーン・ミング
Christine Ming
1994

95.
エドワード・メイプルソープ
Edward Mapplethorpe
メロディ
Melody
1988

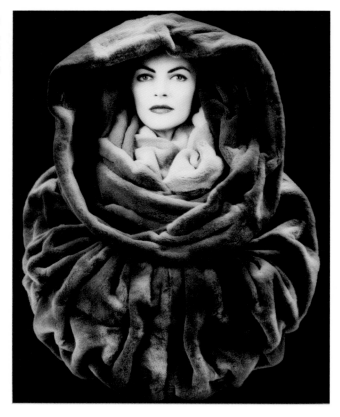

96.
ブリジット・ポレミス
Brigitte Polemis
モハメド・アリ
Muhammad Ali
2010

97.
ジーニー
Genie
無題
Untitled
N/D

98.
ジーニー
Genie
無題
Untitled
N/D

99.
スコット・リフシュルツ
Scott Lifschultz
無題
Untitled
2004

100.
サイ・ロス
Cy Roth
芸者
Geisha
N/D

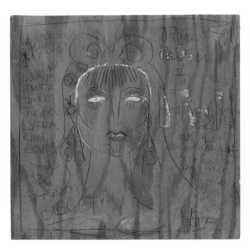

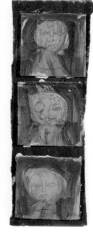

102.
ベビー・グレガー
Baby Gregor
木板に描かれた顔
Faces on Wood Panel
N/D

101.
ベビー・グレガー
Baby Gregor
ポートレート
Portrait
1994

103.
リーヴィス・アイトル
Reavis Eitel
容赦なきミング
Ming the Merciless
2008

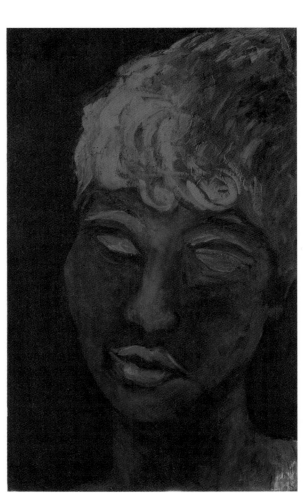

104.
キャット・ルース
Katt Ruth
無題
Untitled
1983

105.
ピエール・シャンドラ
Pierre Chandra
無題
Untitled
N/D

106.
エドワード・ダンコナ
Edward D'Ancona
ハリウッド・ピンナップ ガール
Hollywood Pinup Girl
N/D

107.
アンドレ・ウォーカー
Andre Walker
無題
Untitled
c. 1983

124

108. (左/Left)
作者不詳
Unknown
ザ・ハウス・オブ・デュプリー主催のボールプログラムの表紙
Cover of Paris is Burning Ball Program, organized by the House of Dupree
1986

109. (右/Right)
フィリス・ディラー
Phyllis Diller
ヴィクトリア
Victoria
N/D

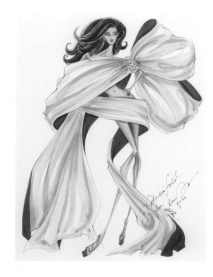

111.
アーロン・ポッツ
Aaron Potts
愛の贈り物
The Gift of Love
2008

110.
ステラ
Stella
聖母マリア
Mary
N/D

112.
作者不詳
Unknown
無題
Untitled
N/D

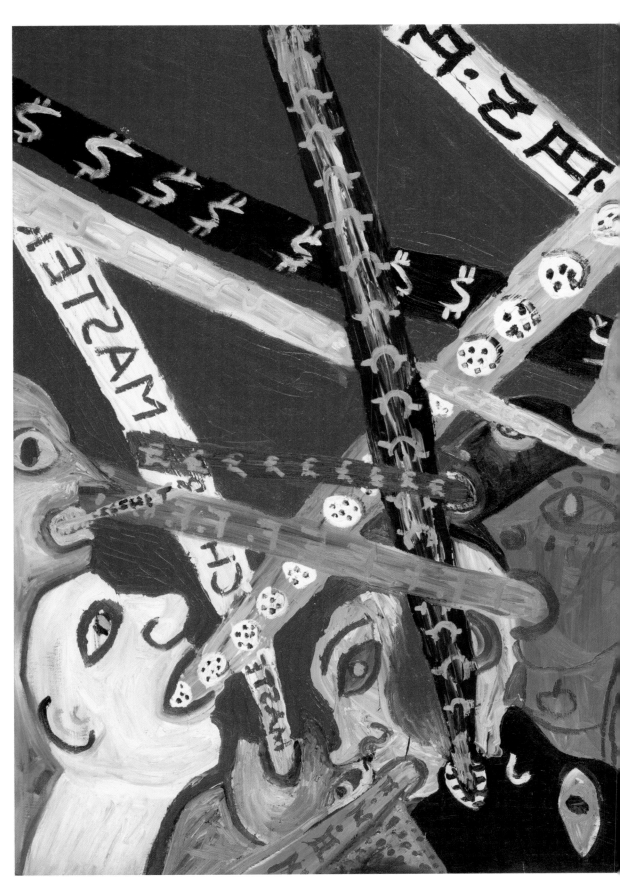

113.
作者不詳
Unknown
無題
Untitled
N/D

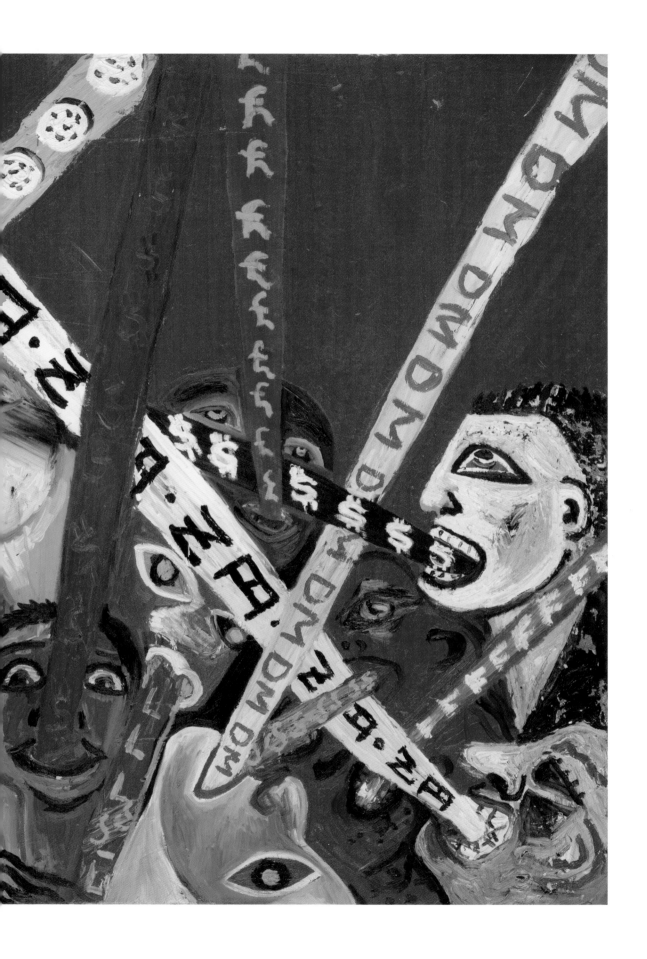

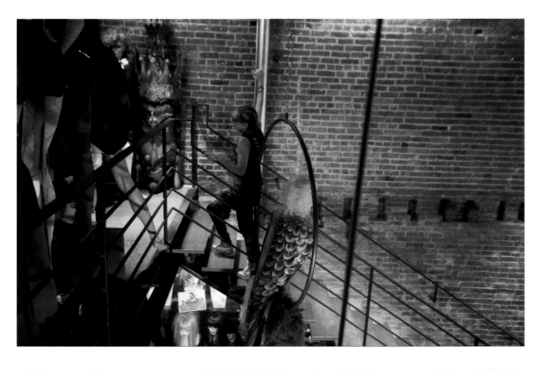

パトリシア・フィールド・アートコレクションにフィールド自身の肖像が多く含まれるのは、この稀有なアートコレクションのもう一つの特徴である。ブティックに集うアーティストに多くの影響を与えたフィールド。アーティストが個々に築き上げてきた独自の視座とスタイルは、フィールドとの出会いにより新たな価値を持つこととなった。
これから紹介するフィールドの姿を捉えた肖像の数々は、生業やライフワークとして創作活動を行うアーティストによるものだけでなく、より親密な関係性から生まれた贈り物も含まれる。ここに掲載する作品は、アーティストたちのキャリアの通過点でもあり、作家とフィールドとの絆の証でもある。

One of the distinctive features of the Patricia Field Art Collection is the abundance of portraits depicting Field herself. Field, who has greatly influenced the artists gathered in her boutique, has given their individual perspectives and styles a new value through their encounters with her. The collection not only includes portraits created by artists who engage in creative expression as their profession or life's work but also encompasses gifts born from more intimate relationships. The artworks presented here serve as milestones in the artists' careers and testaments to the bond between the artists and Field.

PORTRAITS OF PATRICIA FIELD｜パトリシア・フィールドの肖像

114.
アーロン・コベット
Aaron Cobbett
パトリシア・フィールド
Patricia Field
1998

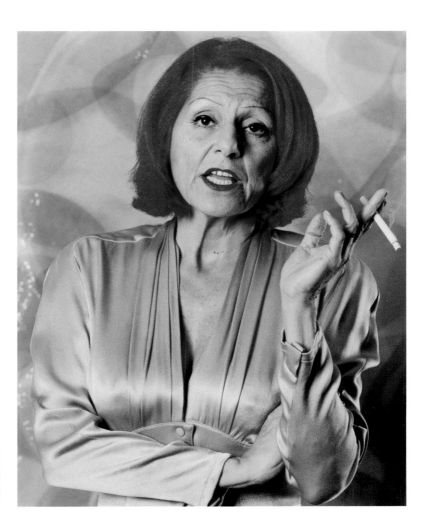

115.
作者不詳
Unknown
無題
Untitled
N/D

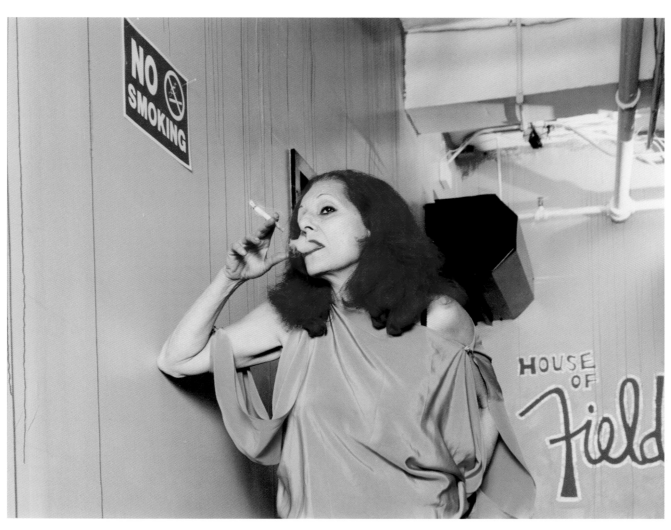

116.
カリン・コールバーグ
Karin Kohlberg
ノー・スモーキング
No Smoking
2003

117.
レオナード
Leonard
パトリシア・フィールド
Patricia Field
1999

118.
スコット・イーワルト
Scott Ewalt
パトリシア・フィールド
Patricia Field
2003

119.
ダニエル "ディー" コルッチ
Danielle "Dee" Colucci
パトリシア・フィールド
Patricia Field
N/D

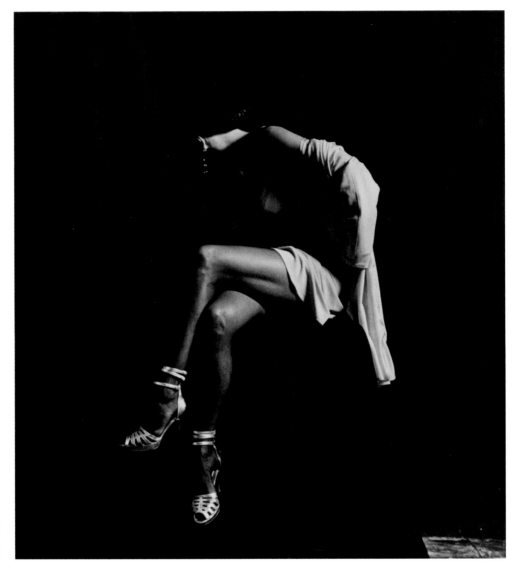

120.
マーカス・レザーデイル
Marcus Leatherdale
パトリシア・フィールド
Patricia Field
1988

121. (左/Left)
パトリック・マクマラン
Patrick McMullan
パトリシア・フィールド
Patricia Field
N/D

122. (右/Right)
ドン・パトロン
Don Patron
ビッグ・レッド
Big Red
2007

123.
ワンダ・アコスタ
Wanda Acosta
パトリシア・フィールド、インドシン・ニューヨーク
Patricia Field, Indochine NY
2010

124.
進藤祐光
Yuko Shindo
パトリシア・フィールド
Patricia Field
1994

125.
オーラン
Olan
パトリシア・フィールドのポートレート
Portrait of Patricia Field
N/D

126.
森田彩愛
Sae Morita
ハッピー・バースデー
Happy Birthday
2015

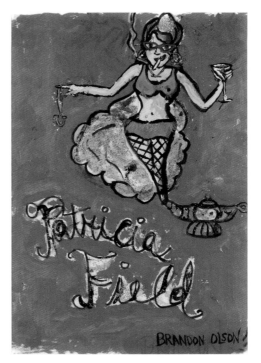

127.
ブランドン・オルソン
Brandon Olson
私の自由の女神
My Statue of Liberty
N/D

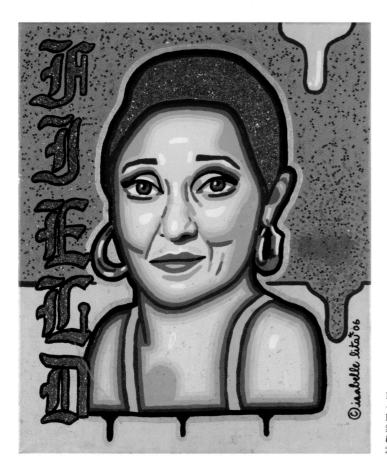

128.
イザベル・リタ
Isabelle Lita
無題
Untitled
2006

129.
ポール・スタイニッツ
Paul Steinitz
無題
Untitled
2000

130.
ポール・スタイニッツ
Paul Steinitz
無題
Untitled
2000

131.
ポール・スタイニッツ
Paul Steinitz
無題
Untitled
2000

132.
ポール・スタイニッツ
Paul Steinitz
無題
Untitled
2000

133.
ノエル・スアレス
Noel Suarez
ラ・パット・フィールド
La Pat Field
2003

134.
作者不詳
Unknown
サラ・ジェシカ・パーカーとパトリシア・フィールド
Sarah Jessica Parker and Patricia Field
c. 2000

140

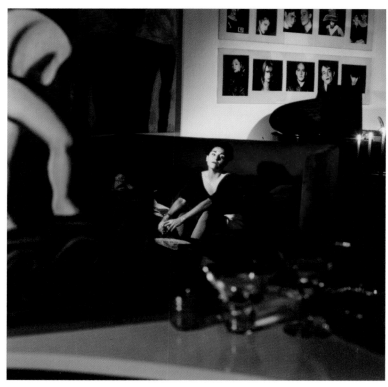

135.
作者不詳
Unknown
パトリシア・フィールド
Patricia Field
N/D

136.
作者不詳
Unknown
パトリシア・フィールド
Patricia Field
N/D

137.
作者不詳
Unknown
パトリシア・フィールド
Patricia Field
N/D

Patricia Field at Paris DuPree Ball at Trax, NYC 3/12/89

PATRICIA FIELD
パトリシア・フィールド

聞き手：梁瀬薫
美術評論家／展覧会プロデューサー
国際美術評論家連盟米国支部会員
中村キース・ヘリング美術館顧問

協力：エリカ・グスマン
パトリシア・フィールド・アートファッション
エグゼクティブ・アドミニストレーター

梁瀬薫（以下 **K**）　あなたのアートに関する一番最初の記憶、アートがあなたに与えた影響についてお話しいただけますか。

パトリシア・フィールド（以下 **P**）　私にとって創造性はとても魅力的なもので、アートは母なる創造性の子供の一つです。私はいつも、さまざまなアーティスト、画家、彫刻家、そしてもちろんデザイナーと関わることを楽しんできました。それが私の人生なのです。

K　現在、中村キース・ヘリング美術館には、あなたのコレクションが約200点収蔵されており、新しいカタログ（本書）にも掲載されています。キース・ヘリングをはじめとする著名なアーティストから無名のアーティストまで、さまざまなアーティストがコレクションされていますが、作品を選ぶ際に特に注目している点はありますか？

P　その質問はとても興味深いものです。作品って自然と同じで、喜びを与え、気持ちよさだとかハッピーな気持ちにさせるものだと思います。絵画やアーティストを選ぶときにはいつもそう考えています。いろんなアーティストやスタイルが存在していて、私は特定の芸術の流派やアーティストにこだわっているわけではないので。

K　コレクションのほとんどは、8丁目の「パトリシア・フィールド」で集めたのですか？それとも「ホテル・ヴィーナス」で集めたのでしょうか？

P　作品蒐集は8丁目で始まったと思います。そして、「ホテル・ヴィーナス」でも続きました。実はここ（アートファッション・ギャラリー）にも、「ホテル・ヴィーナス」の壁画を描いた画家の一人、ジョナサン・ブレスラーの作品があるんです。生涯にわたって交流している仲間や友人、アーティストがいるんです。

K　壁画やその他のコミッションワークのために、アーティストに特定の作品を依頼したことはありますか？

P　アーティストとの関係でいえば、私は何かを見るときそれが話しかけてくるかのような感覚があります。私は編集者ではないので、そのまま受け取るか、そのままにしておくのが好きです。理解できないものは、手放さなければならない。でも、もしそれが私にインスピレーションや喜びを与えてくれるのであれば、自宅やギャラリー、あるいはショップや8丁目、「ホテル・ヴィーナス」など、私の生活の場所に置きたいですね。

K　例えば、試着室のドアにスティーブン・ブロードウェイに絵を描いてもらうとき、特にリクエストはしなかったのでしょうか？

P　彼の作品はすでに知っていましたから、特に何もお願いしませんでした。私は編集者ではないのです。私は、アーティストの芸術的価値に影響を与えたいわけではありません。例えば、スクーター・ラフォージのように、一貫性があり、自分のスタイルを持っているアーティストが好きなんです。

K　印象に残っていることといえば、ジャン＝ミシェル・バスキアがお店に来て、床に絵を描いていたそうですね。

P　ええ、そうです。ジャン＝ミシェルは「グレイ」というバンドをやっていたのですが、初めて8丁目の私の店の上にあるロフトに来たとき「ここでリ

ハーサルをさせてもらえないか?」と聞かれたので、私は「もちろん。やってみれば?」と言いました。それで彼らはよく私のロフトにやってきてリハーサルをしていたんです。ほら、そういう時代ってよかったですよね。本当にいい時代だった。どんなに特別な時代を生きたか、みんな気づいていないですよね。

K 彼の音楽は好きだったんですか?

P ええ、好きでしたよ。繰り返しになりますが、私はあまり編集をしようとしません。何が言いたいかというと、共感するかしないか、どちらかということです。元の表現のままがいいんです。

K コレクションの中には、さまざまなアーティストによるあなたのポートレートがありますね。

P そうそう、そうなんです。

エリカ・グスマン(以下 E)そうですね。今でもリチャード・アルバレスのようなアーティストたちはあなたにインスパイアされていますよね。

P すごい。自分ではそんな風に思っていないんです。私はただ、自分のことをやっているだけだから……以前は自分の店で、今は「アートファッション・ギャラリー」のことを。ここはとても気に入ってます。このギャラリーへは、私の好きなアーティストやデザイナーを連れてきました。店をソーホーからバワリーに移し、ここに来たときにはすぐ近くにアパートを買い、「アートファッション・ギャラリー」という小さなギャラリーを作れないかと考えたんです。店を持つとなると、買い付けに行ったり、いろいろと面倒なことがありますよね。それが私の

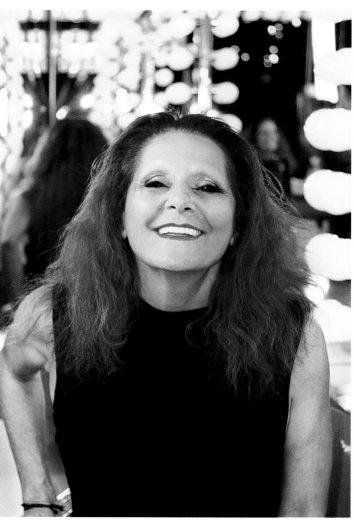

Patricia Field at 302 Bowery store, 2011

ギャラリーではアーティストが発明品や作品を持ってくるから、買い物のための移動よりも少し楽なんです。昔、私の店ではハローキティがとても人気だったんです。ハローキティがきっかけで日本との交流が始まり、何度も買い物に出かけました。もちろん、そこで友達もできたし、日本は私の人生において大きな一部となりました。

K 当時の東京への旅行や、そこでできた友人について詳しく教えてください。

P 原宿は、私たちがいたニューヨークのダウンタウンを想起させる若者の街でした。倍子1のようにそこでお店をやっている方々にもお会いし

ました。新しいものに目を向けられた時期でした。現在も私たちは交流を続けています。

K 現在でも作品蒐集を継続していますか?

P 今でも続けています。私のアパートには、リチャード・アルバレスのガラスに描かれた絵が壁一面に飾られています。このような独創的な才能を見ることで喜びを感じますし、自分の生活の中にそれがあることで気分が良くなりますね。

E あなたの寝室には、ファレス・リズクに依頼した巨大な絵も飾ってありますね。

P そうそう、あの大きい作品ですね。

K 「アートファッション・ギャラリー」のために、どのようにアーティストを選んでいるのでしょうか?

P オリジナリティがあるかどうか、それが私にとってはとても重要な要素です。それが絵画であれ、ファッションであれ、私の目を見開かせるような「すごい」と思わせるようなもの。例えば、スクーター・ラフォージには彼だけの特性があり、みんなが彼の作品を認識できます。それがとても嬉しいんです。

E 新しいアーティストもいますよ。チリ出身のマリアさん。

K 常に新しいアーティストがいるんですね。

P はい、人が来てくれるのはいいことです。嬉しいですね。どんな理由であれ、私のことやこのギャラリーのことを知ってくれていて、来てくれるから、一緒に何かをできるんです。

K 今、どんなファッションに興味がありますか?どんなものがお好きなのでしょうか?

P 最近のファッションには、まあここ何年かで良くはなってきてるとは思うのですが、正直目に入ってくるものには幻滅していました。想像力に欠け、ポジティブでもない。でも、そのおかげで、ファッションに関する理論、哲学的な理論が身につきました。そして、絵画であれ、衣服であれ、クリエイティブな表現であれ、その創造を生み出すのは私たちが経験する時間なのだということに気づいたんです。衣服ってその時代を物語っていると

145

思うんです。例えば、仕事でパリに滞在していたとき上司のダレン・スターと電話で話していて、「ダレン、今から外に出て、フランスのシックな女の子たちをチェックするよ」と言いました。街を歩いてみると、スニーカーにジーンズ、スウェットパーカーを着た女の子たちばかり。「一体、パリのファッションはどこに行ったの?」と思いました。このようなファッションは世界中に広まっています。でも、これは経済を反映していると思うんです。私の勝手な想像ですが、第一次世界大戦後、1920年代の高揚した雰囲気が足首まであったスカートの丈をより短くさせた、というように。クレージュやカルダンも…そのときの文化の雰囲気を反映しているんです。だから、最近のファッションはなんか鬱屈とした服が多いというか。サイズが合わない、印象的な色でもない、色褪せている、とか。そう思いませんか? でも、そこから脱却しつつあると気づいてはいるんです。パリに行ったときショックだったのは、スウェットパンツ、パーカー、スニーカー……ここアメリカもそうですが、まさかパリもそうだとは思わなかったから。表現とは、その時代の文化を物語るものなのだと考えるようになりました。

K　子供の頃からアートがお好きだったのですか?

P　実は、子供の頃は表現としてのファッションが好きだったんです。私の本2の中でカウガール時代のことを話していますが、私はその衣装が大好きでした。「ファッション」ではなくて、どちらかというと「表現」に近いものですね。

K　絵画や彫刻を見たとき、その第一印象を覚えていますか?

146

P　キース・ヘリングの作品を初めて見たときは目を奪われましたね。私のアパートには彼の木彫りの作品があります。また、中東出身の友人による中東の女性が描かれた大きな絵画もありますよ。私は絵画であろうとファッションであろうと、アートが大好きです。それは表現であり、個人的なものです。生で、直接的で、フィルターを通さないからこそ、その人に近づくことができるのです。

K　あなたはアートに対してとても独創的な目を持っていますね。

P　ええ、そうですね。私の目は……何かを見てハッピーになるか、前進できるか、どちらかです。見てみないとわからないけどそれが自分をハッピーにしてくれるということはもちろん大事、幸せであることはとても大切ですから。

K　ありがとうございました、パットさん。

［2023年4月14日（金）アートファッション・ギャラリーにて］

注釈

1. ファッションブランド「Ash&Diamonds」の創始者、加藤倍子。

2. *Pat in the City: My Life of Fashion, Style and Breaking All the Rules* (Deyst, 2023)

INTERVIEW WITH PATRICIA FIELD

Interviewer: Kaoru Yanase

Art Critic / Exhibition Producer
AICA (Association of International Art Critics U.S.A)
Senior Advisor at Nakamura Keith Haring Collection

Support: **Erica Guzman**
Executive Administrator at Patricia Field ARTFashion

Kaoru Yanase (K) Can you share some of your earliest memories or influences that art had on you?

Patricia Field (P) For me, creativity is very attractive, and art is one of the children of the Mother Creativity. I grew up surrounded by art, with my parents taking me to museums and galleries. I have always enjoyed having relationships with different artists, painters, sculptures, and of course, designers. That's my life.

K As the Nakamura Keith Haring Collection now houses around 200 artworks of your collection, and you'll see them in the new catalog, I want to ask you. Considering all the artists of your collection varying from the famous, including Keith Haring, to the unknown, are there any particular points of interest that you look for when choosing art pieces?

P Your question is very interesting because I feel that the artwork, like your environment, has to give you pleasure and has to make you happy. That was always my method of choosing a painting or an artist. There are so many different artists and styles, and I prefer it that way because I don't feel as though I am in one school of art and artists.

K Was most of your art collection built up at the 8th Street location of your boutique, or was it at Hotel Venus?

P The collection, I guess, started at 8th Street and continued on in Hotel Venus. Actually, even here, one of the painters who painted the murals in Hotel Venus, Jonathan Bressler, is still with me. It's a lifetime of associates, friends, and artists.

K Have you asked the artist to make particular art for a mural or any other commission works?

P My relationship with the artist is such that if I see something and it talks to me, I'm not an editor. I like to take it as it is or leave it and let it go. If I don't understand it, I have to let it go. But if it gives me inspiration or pleasure, then I want it next to me — in my home, gallery, or wherever my environment is, like in my shop, 8th Street, or Hotel Venus.

K When you asked, for example, Steven Broadway to draw on the fitting room doors, did you have particular requests?

P I knew his work, so I didn't ask him to do anything in particular because I already knew what I was getting into. As I say, I am not the editor. I prefer not to influence the artistic value of the artist. I like artists like Scooter LaForge, who are consistent and have their own style.

K Speaking of memorable times, you mentioned Jean-Michel Basquiat used to come into your store and paint on the floor.

P Yes, definitely. Jean-Michel had a band called Gray, and the first time he came to my loft, which was above my shop on 8th Street, he asked if they could rehearse there. I said, "Yes, sure, why not?" So they used to come and rehearse in my loft. You know it was those great times. Really, they were wonderful times. I don't think we realized how special those times were.

K Did you like his music?

P Yeah, I did. But, again, I don't try to do a lot of editing. I either relate to it, or I don't. I prefer it in its original expressive state.

K In your collection, you have many of your portraits by different artists.

P Oh yes, that's true.

Erica Guzman(**E**) Even now, artists like Richard Alvarez get inspired by you all the time.

P Wow. I never think of myself that way. I'm just doing my thing — my ARTFashion Gallery now, my store before. I love being here because I brought designers and artists when I opened up this fashion art gallery. And I need that in my life, so when I left my Soho store, moved to Bowery, and then came here, I bought an apartment very close. I thought, "Well, maybe I could do a little ARTFashion Gallery." It's a bit easier than the traveling required for shopping.
There was a time when Japanese pieces were popular in my shop. Hello Kitty started my Japanese trips for shopping. I made friends there, and it was a big slice of my life.

K Can you tell us more about your trips to Tokyo back then and the friends you made there?

P Harajuku reminded me of Downtown New York. I met several people who had shops there, like Masuko[1]. It was a time when my eyes opened to something new. Young Japanese culture was fascinating. To this day, we still see one another.

K Are you still collecting art?

P I still do. In my apartment, I have a wall-to-wall painting on glass by Richard Alvarez. I get pleasure from seeing original talent.

E You also commissioned Fares Rizk to do a huge painting in your bedroom.

P Oh right, right. I have that big one.

P If I see originality, that is a very important factor for me. Whether it's a painting or fashion. We have several designer artists in the gallery, like Scooter LaForge, who has a signature. People recognize him. And it makes me very happy.

E We have a new artist, Maria from Chile.

K I see you constantly have new artists.

P Yes. It's good people come. For whatever reason, they know about me or the gallery, they visit, and we do things together.

K What is your interest in fashion right now? What do you like?

P Well, you know, these days, I have to admit, but I think it's getting better for about a year or more, even I was very disillusioned with what I was seeing. It was not imaginative. It was not positive. Actually, it gave me, let's say, a theory, a philosophical theory about fashion. And I realized that it's the time that we experience that creates, whether it's a painting or garment or something creative that's expressive. I think that it definitely tells the story of the time it's coming from. So, I found, recently, the last couple of years, I was very... For example, I was in Paris, and I was on the phone with my boss, Darren Starr, and he was still in the U.S. I said, "Darren, I'm going to go out now and check out all the French chic girls." So I go outside, all these girls are in sneakers, jeans, and sweat hoodies. I'm like, "Where's the Paris fashion?" It became worldwide — this sort of, I guess, look. But I think it reflects the economy. For example, I guess my idea is, after World War I, by the way, I just pieced it together, it was like in the 20s, and the mood was so high, and, you know, the skirts went from ankle-high to showing more. Courrèges, Cardin... And it reflects the mood of the culture at that time. But recently, a lot of fashion looked like depression wear, with ill-fitting garments and faded colors. However, I think we're coming out of it. When I was in Paris, I expected to see chic fashion, but instead, I saw sweatpants, hoodies, and sneakers. This made me realize that expressions in fashion tell the story of the culture at the time.

K Have you always loved art since your childhood?

P As a child, I loved fashion as an expression. In my book[2], I talk about my cowgirl days, and I loved the costume. It wasn't about fashion but more like an expression. My love for art came naturally as I was exposed to it at an early age.

K Do you remember your first impression of seeing some paintings or sculptures?

P From the first day I saw Keith Haring's work, it caught my eye. I have a woodcut piece of his in my apartment. I also have a large painting of a Middle Eastern woman by a friend from the Middle East. I love art, whether it's a painting or a fashion piece. It's an expression, and it's personal. It brings you close to the person because it's raw, direct, and unfiltered.

K You have a very original eye for art.

P Yeah, I guess I do. My eye can see something that either makes me happy or, you know, I move on. If I don't recognize it, I don't pay attention to it, but if it makes me happy, then it's important, of course, because happiness is very important.

K Thank you, Pat.

[This interview was conducted at Patricia Field ARTFashion Gallery on April 14, 2023.]

Footnotes

1. Masuko Kato, the founder of the Japanese fashion brand Ash & Diamonds.

2. *Pat in the City: My Life of Fashion, Style and Breaking All the Rules* (Deyst, 2023)

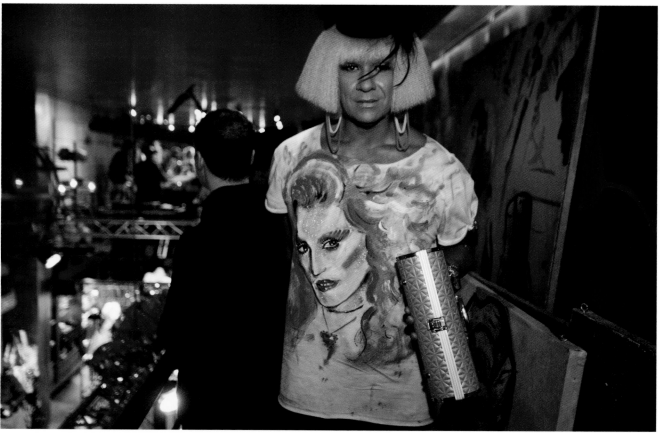

Gazelle Paulo wearing Scooter LaForge at Patricia Field store opening party

> *In my shop, I had the pleasure of meeting many different creative people, both in and out of fashion. This gave me the opportunity of amassing my art collection, which is now exhibited at the Nakamura Keith Haring Collection.*
>
> *This collection is personal to me as each piece of art represents someone special in my life. Some were gifted to me, some purchased by me, but the collection represents a major piece of my life in New York.*

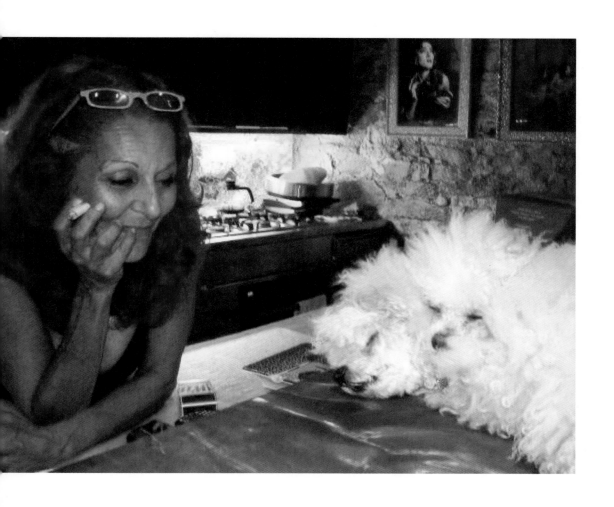

私の店では、ファッション関係に限らず、たくさんのクリエイティブな人たちに出会うことができました。それがきっかけとなって、私のアートコレクションは膨らんでいき、ついには中村キース・ヘリング美術館で展示されています。

このコレクションはとても個人的なものであり、一点一点が私にとって特別な人たちの象徴でもあります。贈られたものや購入したもの、どれもが私のニューヨーク人生の大きな一部なのです。

パトリシア・フィールド

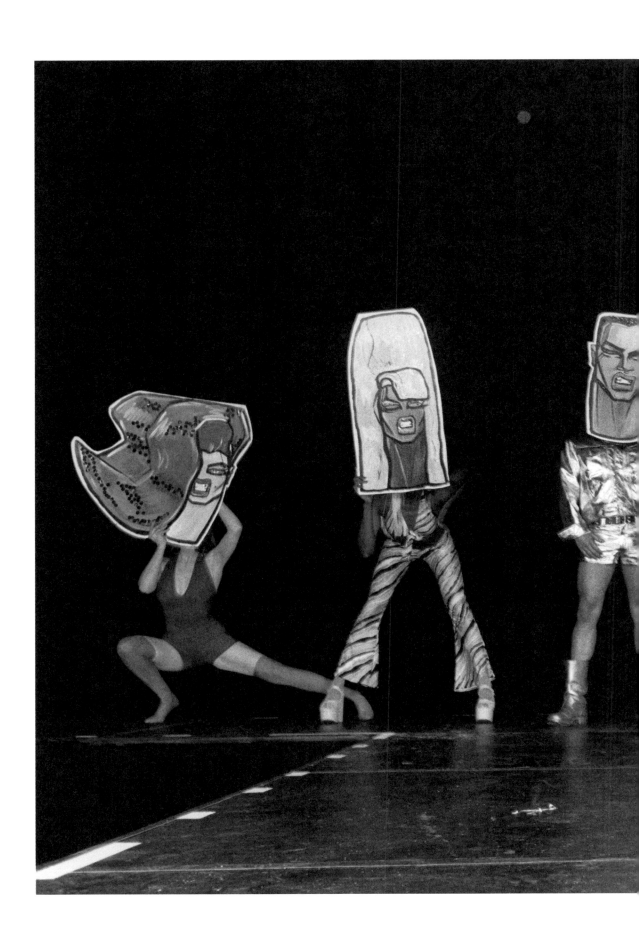

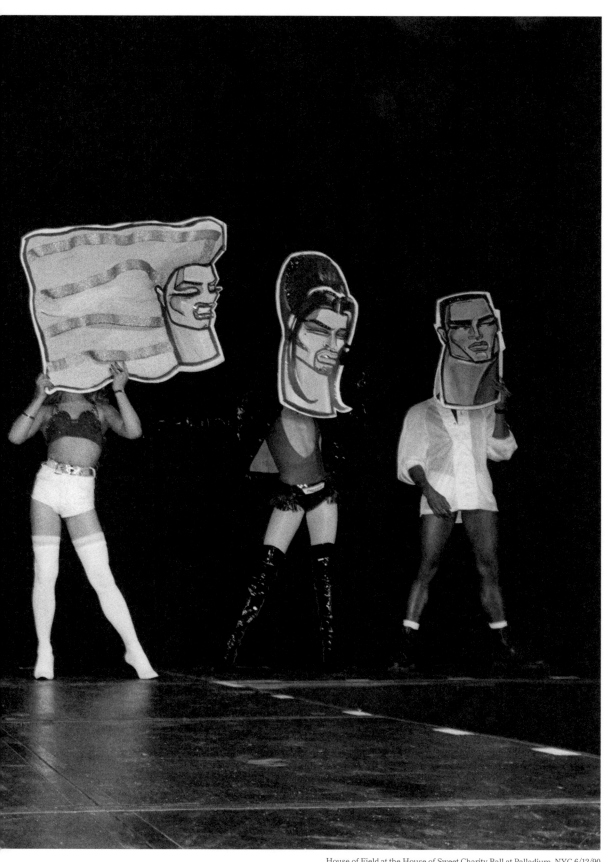

153

House of Field at the House of Sweet Charity Ball at Palladium, NYC 6/12/90

パトリシア・フィールド
年譜

※色分けはブティックの変遷

1942年	仕立て屋として働くアルメニア系の父と洗濯屋で働くギリシャ系の母の間にニューヨーク市で生まれ、クイーンズ区アストリアで育つ
1963年	ニューヨーク大学卒業
	在学中は哲学と政治学を学び、卒業後はアパレル販売員として仕事を始める
1966年	グリニッジビレッジのワシントンプレイス通り14番地にブティック「パンツ・パブ」をオープン（-1971年）
1971年	東8丁目10番地に移転、ブティック「パトリシア・フィールド」をオープン（-2002年）
1970年代	女性用のレギンスを開発
1987年	映画『愛は危険な香り』、『彼が彼女にきがえたら』、『クライム・ストーリー』衣装デザイン
1988年	ハウス・オブ・フィールドがニューヨークのダウンタウンにハーレムボールを紹介する「グランド・ストリート・ボール」を開催
1989年	映画『ディア・ダイアリー』衣装デザイン
1990年代	ブティック「パトリシア・フィールド」でハローキティグッズの取り扱いを始め、クラブキッズを通してその人気の火付け役となる
1990年	GMHCによるセーフ・セックスキャンペーン映像『ゴッツ・トゥ・ビー・ア・ドラァグ』に衣装提供
	『マザーグース・ロックン・ライム』でエミー賞受賞
	映画『ワイズガイ』、『グレープヴァイン』衣装デザイン
1992年	東8丁目のブティック「パトリシア・フィールド」と並行して、6番街408番地にショップをオープン（-1994年頃）
1993年	映画『オンリー・ザ・ストロング』、テレビドラマシリーズ『サウスビーチ』衣装デザイン
1995年	映画『マイアミ・ラプソディー』の撮影中にサラ・ジェシカ・パーカーと知り合い、これが後に『セックス・アンド・ザ・シティ』の仕事につながる
1996年	映画『野獣教師』衣装デザイン
	ウエストブロードウェイ382番地にブティック「ホテル・ヴィーナス」をオープン（-2006年）
1998年	テレビドラマシリーズ『スピン・シティ』、テレビドラマシリーズ『セックス・アンド・ザ・シティ』衣装デザイン
2000年	『セックス・アンド・ザ・シティ』で衣装デザイナー組合賞受賞
	テレビドラマシリーズ『ザ・ストリート』衣装デザイン
2001年	『セックス・アンド・ザ・シティ』で衣装デザイナー組合賞受賞
2002年	『セックス・アンド・ザ・シティ 恋愛関係の測り方』でエミー賞受賞
	ドラマ『ガイディング・ライト』衣装デザイン（-2009年）
2003年	テレビドラマシリーズ『ホープ＆フェイス』衣装デザイン
2004年	『セックス・アンド・ザ・シティ』で衣装デザイナー組合賞受賞
2005年	『セックス・アンド・ザ・シティ』で衣裳デザイナー組合賞受賞
2006年	映画『プラダを着た悪魔』衣装デザイン
	『プラダを着た悪魔』でサテライト賞受賞
	バワリー302番地に移転（-2012年）
2007年	テレビドラマシリーズ『アグリー・ベティ』、『カシミアマフィア』衣装デザイン
	『プラダを着た悪魔』でアカデミー衣装デザイン賞にノミネート
2008年	『キャス＆キム』衣装デザイン（-2009年）
	映画『セックス・アンド・ザ・シティ ザ・ムービー』衣装デザイン、リール映画祭で受賞者6名のうちの一人となる
	安室奈美恵のシングル『60s 70s 80s』収録の3曲「NEW LOOK」、「ROCK STEADY」、「WHAT A FEELING」のミュージックビデオ、およびアンナ・ヴィッシのアルバム『Apagorevmeno』収録の「Sti Pira」「Alitissa Psihi」のミュージックビデオ衣装デザイン
	「FASHION × MUSIC × VIDAL SASSOON」キャンペーンのためにモデルを務めた安室奈美恵の衣装をデザインし、300体限定でその衣装をまとったバービー人形がリリースされる
2009年	映画『お買いもの中毒な私！』衣装デザイン
	『アグリー・ベティ』で衣装デザイナー組合賞受賞
	キース・ヘリング作品とのコラボレーショングッズを展開
2010年	「メルセデス・ベンツ・ファッションウィーク2010秋」で「Keith Haring by House of Field / Paradise Garage Collection Exhibition」発表
	映画『セックス・アンド・ザ・シティ2』衣装デザイン
	中国の長編映画『杜拉拉昇職記（Go Lala Go!）』衣装担当
	『セックス・アンド・ザ・シティ2』衣装デザイン
2011年	台湾のテレビドラマ『マテリアル・クイーン』衣装担当
2012年	バワリー306番地に移転（-2016年）
2014年	映画『ダメ男に復讐する方法』衣装デザイン
2015年	テレビドラマシリーズ『サバヨミ大作戦！』衣装デザイン
2016年	映画『ガール・オン・ザ・トレイン』衣装デザイン
2018年	イーストブロードウェイ200番地に「パトリシア・フィールド・アートファッション・ギャラリー」をオープン（-現在）
	映画『セカンド・アクト』、テレビドラマシリーズ『TVキャスター　マーフィー・ブラウン』衣装デザイン
2019年	映画『TVキャスター　マーフィー・ブラウン』、『アザーフッド　私の人生』衣装デザイン
2020年	Netflixドラマシリーズ『エミリー、パリへ行く』、テレビドラマシリーズ『ラン・ザ・ワールド』衣装デザイン
2021年	『エミリー、パリへ行く』で衣装デザイナー組合賞受賞
2023年	回想録『Pat in the City: My Life of Fashion, Style and Breaking All the Rules』出版
	ドキュメンタリー映画『Happy Clothes: A Film About Patrciai Field』がトライベッカフィルムフェスティバルで公開

1942	Born in New York City to a tailor father of Armenian descent and a Greek mother who worked at a laundry. Raised in Astoria, Queens.
1963	Graduated from New York University, where she studied philosophy and political science. Began working as an apparel salesperson after graduation.
1966	Opens boutique The Pants Pub at 14 Washington Place (–1971)
1971	Opens Patricia Field at 10 East Eighth Street (–2002)
1970s	Invents leggings for women.
1987	Costume designer for film *Lady Beware*, *He's My Girl* and *Crime Story*
1988	House of Field hosts the Grand Street Ball, introducing Harlem ball culture to downtown New York.
1989	Costume designer for film *Dear Diary*
1990s	Brought Sanrio's Hello Kitty to the Patricia Field boutique and becomes the catalyst for its popularity through Club Kids
1990	Provides costumes for GMHC's *GotsToBeADrag* safe sex campaign, and wins an Emmy award for *Mother Goose Rock 'n' Rhyme* in the category of Outstanding Costume Design for a Variety or Music Program. Also costume designer for films *Wiseguy* and *Grapevine*.
1992	Opens another Patricia Field at 408 Sixth Avenue (–c.1994)
1993	Costume designer for film *Only the Strong* and TV series *South Beach*
1995	Meets Sarah Jessica Parker while working on the film *Miami Rhapsody*, which leads to her work on *Sex and the City*
1996	Costume designer for film *Beautiful Thing* and *The Substitute*
	Opens Hotel Venus at 382 West Broadway (–2006)
1998	Costume designer for TV series *Spin City* and *Sex and the City*
2000	Wins Costume Designer Guild Award for *Sex and the City*
	Costume designer for TV series *The Street*
2001	Wins Costume Designer Guild Award for *Sex and the City*
2002	Wins Emmy for *Sex and the City: Defining Moments*
	Costume designer for *The Guiding Light* (–2009)
2003	Costume designer for TV series *Hope & Faith*
2004	Wins Costume Designer Guild Award for *Sex and the City*
2005	Wins Costume Designer Guild Award for *Sex and the City*
2006	Costume designer for film *The Devil Wears Prada*
	Wins a Satellite Award for *The Devil Wears Prada*
	Moves the boutique to 302 Bowery (–2012)
2007	Costume designer for TV series *Ugly Betty* and *Cashmere Mafia*
	Nominated for an Academy Award for Costume Design for *The Devil Wears Prada*
2008	Costume designer for *Kath & Kim* (–2009)
	Costume designer for *Sex and the City: The Movie*, 6 out of the 7 winners of the Reel Time Film Festival
	Costume designer for Namie Amuro's music video *New Look*, *Rock Steady*, and *What A Feeling*, and for Anna Vissi's music video *Sting Pyra* and *Alitissa Psihi*
	Costume designer for Namie Amuro, who served as a model for the FASHION × MUSIC × VIDAL SASSOON campaign. As part of this collaboration, limited edition Barbie dolls wearing those costumes were released, with a total of 300 dolls
2009	Costume designer for film *Confessions of a Shopaholic*
	Wins Costume Designer Guild Award for *Ugly Betty*
	Launches Keith Haring by House of Field
2010	Mercedes-Benz Fashion Week Fall 2010 - Keith Haring by House of Field/Paradise Garage Collection Exhibition
	Costume designer for *Sex and the City 2* and Chinese feature film *Go Lala Go!*
2011	Costume designer for Taiwanese TV series *Material Queen*
2012	Moves the boutique to 306 Bowery (–2016)
2014	Costume designer for film *The Other Woman*
2015	Costume designer for TV series *Younger*
2016	Costume designer for film *The Girl on the Train*
2018	Opens Patricia Field ARTFashion Gallery at 200 E Broadway (–Current)
	Costume designer for film *Second Act* and TV series *Murphy Brown*
2019	Costume designer for film *Murphy Brown* and *Otherhood*
2020	Costume designer for Netflix series *Emily in Paris* and TV series *Run the World*
2021	Wins Costume Designer Guild Award for *Emily in Paris*
2023	Releases memoir *Pat in the City: My Life of Fashion, Style and Breaking All the Rules* Documentary *Happy Clothes: A Film About Patricia Field* to Premiere at Tribeca Film Festival

155

作品リスト
List of Works

凡例
Notes

・本リストは第2章の図版掲載作品について、図版番号、作家名、作品タイトル、制作年、技法・素材、サイズの順に日英で記載した。

・作品サイズは、平面は縦 × 横、立体は高さ × 幅 × 奥行きで記載した。

・画材不詳の作品には、技法・素材を「(支持体)にペイント」と表記した。

・展覧会に出品していない作品には、図版番号の前に「*」を付した。

・ This list provides the plate number, artist name, work title, year of production, technique, material, and size, in both Japanese and English, for the works featured in Chapter 2.

・ The artwork size is listed for two-dimensional works as height × width and for three-dimensional works as height × width × depth.

・ If the art medium is unknown, please indicate "Paint on (support)" in the description.

・ Artworks not included in the exhibition are marked with "*" in front of the numbers.

1.
リチャード・アルバレス
《レス=ビヨンド》
2008年
グリッター、樹脂、ピグメント、ガラス、LED照明
Richard Alvarez
Less‒Beyond
2008
Glitter, resin, pigment on glass, LED light
50.0 × 377.5 × 0.9 cm

*2.
リチャード・アルバレス
《無題》
2001年
グリッター、樹脂、ピグメント、ガラス
Richard Alvarez
Untitled
2001
Glitter, resin, pigment on glass
66.9 × 36.4 × 1.4 cm

*3.
リチャード・アルバレス
《無題》
2005年
グリッター、樹脂、ピグメント、ガラス
Richard Alvarez
Untitled
2005
Glitter, resin, pigment on glass
100.8 × 100.6 × 3.9 cm

4.
ジョジョ・アメリコ
《レッド・デビル》
1998年
アクリル、グリッター、エポキシ樹脂、板
Jojo Americo
Red Devil
1998
Acrylic paint, glitter and epoxy on wood panel
122.0 × 122.0 cm

5.
ジョジョ・アメリコ
《キャット・ウーマン》
2009年
アクリル、グリッター、エポキシ樹脂、板
Jojo Americo
Cat Woman
2009
Acrylic paint, glitter and epoxy on wood panel
122.0 × 122.0 cm

6.
スティーヴン・ブロードウェイ
試着室のドアに描かれたハイヒール
1990年
試着室の木製ドアにペイント
Steven Broadway
High Heel on Dressing Room Door
1990
Paint on wooden dressing room door
122.0 × 60.8 × 1.9 cm

7.
スティーヴン・ブロードウェイ
試着室のドアに描かれたポートレート
1990年
試着室の木製ドアにペイント
Steven Broadway
Portrait on Dressing Room Door
1990
Paint on wooden dressing room door
122.0 × 76.3 × 2.5 cm

8.
スティーブン・ブロードウェイ
試着室のドアに描かれたポートレート
1990年
試着室の木製ドアにペイント
Steven Broadway
Portrait on Dressing Room Door
1990
Paint on wooden dressing room door
122.0 × 91.5 × 2.4 cm

9.
ポール・チェルスタッド
《シー・ペイ・プー》
1987年
クライロンスプレー塗料、キャンバス
Paul Chelstad
Shi Pei Pu
1987
Krylon on canvas
244.5 × 245.0 cm

*10.
ポール・チェルスタッド
《アメリカンフットボール・ビクトリー》
1988年
クライロンスプレー塗料、キャンバス
Paul Chelstad
American Football Victory
1988
Krylon on canvas
183.4 × 122.3 cm

11.
ポール・チェルスタッド
《キース・H》
1990年
クライロンスプレー塗料、パネル
Paul Chelstad
Keith H.
1990
Krylon on found panel
42.8 × 58.0 cm

*12.
ポール・チェルスタッド
《素敵な新しいあなた》
1989年
クライロンスプレー塗料、メゾナイトパネル
Paul Chelstad
Darling New You
1989
Krylon on found Masonite panel
45.7 × 46.0 cm

13.
ポール・チェルスタッド
《擦る前にカバーを閉じる》
1986年
クライロンスプレー塗料、紙
Paul Chelstad
Close Cover before Striking
1986
Krylon on paper
56.5 × 46.5 cm

14.
ポール・チェルスタッド
《1988年に行われたパット・フィールドのファッションショーのための壁画》
1988年
クライロンスプレー塗料、木製パネル
Paul Chelstad
Mural for Pat Field's fashion show in 1988
1988
Krylon on wood panels
229.0 × 489.1 cm (set of 4)

15-19 : 各ページの左から右、上から下の順に
15-19: For each page, please read the captions from left to right, top to bottom.

15.
クレイグ・コールマン
《無題》
1994年
木彫にペイント
Craig Coleman
Untitled
1994
Paint on carved wood
46.0 × 18.3 × 4.0 cm

16.
クレイグ・コールマン
《無題》
1994年
木彫にペイント
Craig Coleman
Untitled
1994
Paint on carved wood
46.0 × 18.1 × 3.7 cm

17.
クレイグ・コールマン
《無題》
1994年
木彫にペイント
Craig Coleman
Untitled
1994
Paint on carved wood
45.6 × 17.9 × 3.7 cm

18.
クレイグ・コールマン
《無題》
1994年
木彫にペイント
Craig Coleman
Untitled
1994
Paint on carved wood
45.4 × 18.7 × 3.8 cm

19.
クレイグ・コールマン
《無題》
1994年
木彫にペイント
Craig Coleman
Untitled
1994
Paint on carved wood
63.3 × 3.9 × 2.8 cm

20.
クレイグ・コールマン
《無題》
1994年
木彫にペイント
Craig Coleman
Untitled
1994
Paint on carved wood
62.1 × 19.0 × 3.8 cm

21.
クレイグ・コールマン
《無題》
1994年
木彫にペイント
Craig Coleman
Untitled
1994
Paint on carved wood
45.4 × 18.4 × 3.8 cm

22.
クレイグ・コールマン
《無題》
1994年
木彫にペイント
Craig Coleman
Untitled
1994
Paint on carved wood
46.0 × 18.7 × 3.7 cm

23.
クレイグ・コールマン
《無題》
1994年
木彫にペイント
Craig Coleman
Untitled
1994
Paint on carved wood
42.1 × 18.7 × 3.8 cm

24.
クレイグ・コールマン
《無題》
1994年
木彫にペイント
Craig Coleman
Untitled
1994
Paint on carved wood
45.9 × 18.2 × 3.8 cm

25.
クレイグ・コールマン
《無題》
1994年
木彫にペイント
Craig Coleman
Untitled
1994
Paint on carved wood
46.0 × 18.5 × 3.4 cm

26.
クレイグ・コールマン
《無題》
1994年
木彫にペイント
Craig Coleman
Untitled
1994
Paint on carved wood
45.7 × 19.0 × 3.8 cm

27.
クレイグ・コールマン
《無題》
1994年
木彫にペイント
Craig Coleman
Untitled
1994
Paint on carved wood
60.2 × 18.4 × 3.8 cm

28.
クレイグ・コールマン
《無題》
1994年
木彫にペイント
Craig Coleman
Untitled
1994
Paint on carved wood
45.7 × 18.4 × 3.7 cm

29.
クレイグ・コールマン
《無題》
1994年
木彫にペイント
Craig Coleman
Untitled
1994
Paint on carved wood
45.6 × 18.1 × 3.8 cm

30.
クレイグ・コールマン
《無題》
1994年
木彫にペイント
Craig Coleman
Untitled
1994
Paint on carved wood
59.1 × 18.4 × 3.7 cm

31.
クレイグ・コールマン
《無題》
1994年
木彫にペイント
Craig Coleman
Untitled
1994
Paint on carved wood
62.1 × 18.2 × 3.8 cm

32.
スクーター・ラフォージ
《パトリシア・フィールドのポートレート》
2014年
油彩、リネン
Scooter LaForge
Portrait of Patricia Field
2014
Oil paint on linen
51.0 × 41.9 cm

33.
マーティーン
《ナメんなよ》
制作年不詳
アクリル、キャンバス
Martine
I'll Kick Your Ass
N/D
Acrylic on canvas
198.3 × 167.5 cm

34.
マーティーン
《銃を持つガール》
1995年
アクリル、キャンバス
Martine
Acrylic on canvas
1995
Paint on canvas
122.0 × 157.5 cm

35.
マーティーン
《カット・アウト・ガール》
制作年不詳
アクリル、板
Martine
Cut Out Girl
N/D
Acrylic on wood board
76.3 × 216.9 cm

36.
マーティーン
《ガール》
制作年不詳
アクリル、板
Martine
Girl
N/D
Acrylic on wood board
122.0 × 81.3 × 2.1 cm

37.
マーティーン
《ガール》
制作年不詳
アクリル、板
Martine
Girl
N/D
Acrylic on wood board
151.0 × 91.4 × 2.1 cm

38.
マーティーン
《ペニス》
制作年不詳
アクリル、板
Martine
Penis
N/D
Acrylic on wood board
121.8 × 60.9 × 1.8 cm

39.
マーティーン
《フェイス》
制作年不詳
アクリル、板
Martine
Face
N/D
Acrylic on wood board
122.0 × 58.6 × 1.8 cm

40.
マーティーン
《3ガールズ》
制作年不詳
アクリル、キャンバス
Martine
3 Girls
N/D
Acrylic on canvas
左(Left) 45.4 × 40.1 cm
中央(Center) 45.9 × 40.5 cm
右(Right) 45.4 × 40.1 cm

41.
マーティーン
ライムライト・ファッションショーのためのポスター
1992年
ポスター
Martine
Poster for Limelight Fashion Show
1992
Poster
42.9 × 28.0 cm

*42.
マーティーン
パトリシア・フィールドによるダイエットコーラ・シティ・コレクション
2008年
Martine
The "Diet Coke" City Collection by Patricia Field
2008
20.6 × 5.9 cm each (set of 4)

43.
スザンヌ・マルーク
《マルコム・エックス、カシアス・クレイ》
1984年
アクリル、キャンバス
Suzanne Mallouk
MALCOM X, CASSIUS CLAY
1984
Acrylic on canvas
117.0 × 137.0 cm

44.
スザンヌ・マルーク
《演説家―マルコム・エックス》
1984年
アクリル、キャンバス
Suzanne Mallouk
ORATOR―MALCOM X
1984
Acrylic on canvas
127.5 × 138.5 cm

*45.
スザンヌ・マルーク
《JFK＆JO》
1985年
アクリル、キャンバス
Suzanne Mallouk
JFK & JO
1985
Acrylic on canvas
137.5 × 117.0 cm

46.
スザンヌ・マルーク
《これなしでは出かけるな》
1985年
アクリル、キャンバス
Suzanne Mallouk
DON'T LEAVE HOME WITHOUT IT
1985
Acrylic on canvas
142.0 × 117.5 cm

47.
ティナ・ポール
《ハウス・オブ・フィールドのパーティー招待券に使われたハウス・オブ・フィールドのオリジナル作品》
1988年
アクリル、写真
Tina Paul
House of Field original artwork for House of Field party invitation
1988
Acrylic on photograph
35.2 × 27.7 cm

48.
ティナ・ポール
《パトリシア・フィールドとレベッカ・ワインバーグのホリデーカード》
1991年
アクリル、写真
Tina Paul
Patricia Field and Rebecca Weinberg Holiday Card
1991
Acrylic on photograph
27.9 × 35.7 cm

49.
ティナ・ポール
《アンドレ・ウォーカーのファッションショーに登場するパトリシア・フィールド》
1985年
アクリル、写真
Tina Paul
Patricia Field in Andre Walker Fashion Show
1985
Acrylic on photograph
50.6 × 41.0 cm

50.
ティナ・ポール
《無題》
1986年
油彩、アクリル、写真
Tina Paul
Untitled
1986
Hand-color oil and acrylic on photograph
27.5 × 35.0 cm

51.
ティナ・ポール
《シティコープ・ビルディング、NYC》
1985年
アクリル、写真
Tina Paul
Citycorp Building, NYC
1985
Acrylic on photograph
35.1 × 27.6 cm

52.
ティナ・ポール
《1984年3月に『イーストビレッジ・アイ』に掲載されたパトリシア・フィールドの広告に登場するデビー・ジェイコブス》
1984年
アクリル、写真
Tina Paul
Debbie Jacobs in Patricia Field Advertisement, published in "East Village Eye," March 1984
1984
Acrylic on photograph
35.3 × 27.7 cm

53.
ティナ・ポール
《無題》
1981年
アクリル、写真
Tina Paul
Untitled
1981
Acrylic on photograph
35.3 × 27.8 cm

54.
ティナ・ポール
《パトリシア・フィールド、東8丁目のロフトにて》
1984年
手彩色、写真
Tina Paul
Patricia Field at her Loft on East 8th Street
1984
Hand-color oil on photograph
24.8 × 19.9 cm

55.
ティナ・ポール
《グレース・ジョーンズ、ハランデールのライムライトにて》
1978年
写真
Tina Paul
Grace Jones at Limelight in Hallandale
1978
Photograph
50.3 × 40.0 cm

56.
ティナ・ポール
《サウスビーチのパトリシア・フィールドとレベッカ・ワインバーグ》
1990年
写真
Tina Paul
Patricia Field and Rebecca Weinberg in South Beach
1990
Photograph
17.8 × 12.6 cm

57.
ティナ・ポール
《サウスビーチのパトリシア・フィールドとレベッカ・ワインバーグ》
1990年
写真
Tina Paul
Patricia Field and Rebecca Weinberg in South Beach
1990
Photograph
20.1 × 25.2 cm

58.
ティナ・ポール
《ユニバーシティプレイスのシバとプリプリ》
1991年
写真
Tina Paul
Sheeba and Pri Pri on University Place
1991
Photograph
27.6 × 35.1 cm

59.
ティナ・ポール
《メドウランズにてモトクロスに参加するパトリシア・フィールドとバーバラ・デンテ》
1987年
写真
Tina Paul
Patricia Field and Barbara Dente Attending Motocross at the Meadowlands
1987
Photograph
27.6 × 35.3 cm

60.
スーザン・ピット
《無題》
制作年不詳
パネルにペイント
Suzan Pitt
Untitled
N/D
Paint on wood board
235.4 × 184.8 cm

61.
スーザン・ピット
《無題》
制作年不詳
キャンバスにペイント
Suzan Pitt
Untitled
N/D
Paint on canvas
182.0 × 126.0 cm

62.
クレイグ・ブランケンホーン
《セックス・アンド・ザ・シティ（キャリー）》
2004年
アーカイバル・デジタル・ピグメント・プリント
Craig Blankenhorn
Sex and the City (Carrie)
2004
Archival digital pigment prints
68.2 × 101.2 cm

63.
クレイグ・ブランケンホーン
《セックス・アンド・ザ・シティ（シャーロット）》
2004年
アーカイバル・デジタル・ピグメント・プリント
Craig Blankenhorn
Sex and the City (Charlotte)
2004
Archival digital pigment prints
68.2 × 101.2 cm

64.
クレイグ・ブランケンホーン
《セックス・アンド・ザ・シティ（サマンサ）》
2004年
アーカイバル・デジタル・ピグメント・プリント
Craig Blankenhorn
Sex and the City (Samantha)
2004
Archival digital pigment prints
68.2 × 101.2 cm

65.
クレイグ・ブランケンホーン
《セックス・アンド・ザ・シティ（ミランダ）》
2004年
アーカイバル・デジタル・ピグメント・プリント
Craig Blankenhorn
Sex and the City (Miranda)
2004
Archival digital pigment prints
68.2 × 101.2 cm

66.
アーロン・コベット
《ケリー"ザ・ボディ"キーシャ》
1989年
Cプリント、木製の手作りフレームにペイント、グリッター
Aaron Cobbett
Kelly "The Body" Keisha
1989
C-Print with handmade wood frame, paint, and glitter
61.2 × 46.0 cm

67.
アーロン・コベット
《ロビー・マーティン》
1989年
Cプリント、木製の手作りフレームにペイント、グリッター
Aaron Cobbett
Robie Martin
1989
C-Print with handmade wood frame, paint, and glitter
61.2 × 46.0 cm

68.
アーロン・コベット
《キモナ117》
1989年
Cプリント、木製の手作りフレームにペイント、グリッター
Aaron Cobbett
Kimona 117
1989
C-Print with handmade wood frame, paint, and glitter
61.3 × 45.7 cm

69.
アーロン・コベット
《レベッカ・フィールド》
1989年
Cプリント、木製の手作りフレームにペイント、グリッター
Aaron Cobbett
Rebecca Field
1989
C-Print with handmade wood frame, paint, and glitter
61.3 × 45.9 cm

70.
アーロン・コベット
《マリア・アヤラ》
1989年
Cプリント、木製の手作りフレームにペイント、グリッター
Aaron Cobbett
Maria Ayala
1989
C-Print with handmade wood frame, paint, and glitter
55.8 × 51.1 cm

71.
アーロン・コベット
《レベッカ・フィールド》
1989年
Cプリント、木製の手作りフレームにペイント、グリッター
Aaron Cobbett
Rebecca Field
1989
C-Print with handmade wood frame, paint, and glitter
61.1 × 46.0 cm

72.
アーロン・コベット
《ザ・ワンズ》
2004年
Cプリント
Aaron Cobbett
The Ones
2004
C-Print
24.8 × 49.3 cm

73.
ジャック・マクヴェイ
《冬の反射 #2（水輪）》
1977年
キャンバスにペイント
Jack McVey
Winter Reflection #2 (with rings)
1977
Paint on canvas
91.3 × 55.7 cm

74.
ドナルド
《マンディ》
1999年
写真
Donald
Mandy
1999
Photograph
15.6 × 10.5 cm

75.
ドナルド
《マンディ II》
1999年
写真
Donald
Mandy II
1999
Photograph
15.5 × 11.1 cm

76.
アーティ・ハック
《イマジネーションを呼ぶあなたのための鏡》
2008年
ミラータイル、目地材、マネキン
Artie Hach
Imagination Calling Mirrors for You
2008
Mirror tiles, white clay grout on mannequin
177.0 × 143.0 × 60.0 cm

77.
カリン・コールバーグ
《アマンダ・レポア、8丁目店にて》
2003年
写真
Karin Kohlberg
Amanda Lepore at 8th Street Shop
2003
Photograph
40.6 × 50.7 cm

78.
サン・シグエンザ
《キャット・ウーマン》
2014年
水彩、インク、化粧品、アクリル、キャンバス
San Sigüenza
Cat Woman
2014
Watercolor, ink, makeup, and acrylic on canvas
91.2 × 61.1 cm

79.
サン・シグエンザ
《キッチュ》
2014年
水彩、インク、化粧品、アクリル、キャンバス
San Sigüenza
Kitsch
2014
Watercolor, ink, makeup, and acrylic on canvas
91.5 × 60.9 cm

*80.
キース・ヘリング
《キース・ヘリング：84年へ…トニー・シャフラジ画廊 個展ポスター》
1983年
オフセット・リトグラフ
Keith Haring
Keith Haring: Into 84… at Tony Shafrazi Gallery
1983
Offset-lithograph on poster paper
89.2 × 58.7 cm
Photo by ©Tseng Kwong Chi

81.
作者不詳
《無題》
制作年不詳
写真
Unknown
Untitled
N/D
Photograph
27.7 × 21.5 cm

82.
作者不詳
《無題》
制作年不詳
写真
Unknown
Untitled
N/D
Photograph
35.5 × 27.8 cm

83.
作者不詳
《無題》
制作年不詳
写真
Unknown
Untitled
N/D
Photograph
15.3 × 10.1 cm

84.
ツェン・クウォン・チ
《パック・ボール（全員集合）、1983》
1983年
ゼラチン・シルバー・プリント
Tseng Kwong Chi
Puck Ball (The Gang's All Here), 1983
1983
Gelatin silver print
92.0 × 92.5 cm

85.
エイドリアン・パナロ
《デイビッド》
1982年
ゼラチン・シルバー・プリント
Adrian Panaro
David
1982
Gelatin silver print
35.4 × 27.8 cm

86.
エイドリアン・パナロ
《ロバート・ルイス》
1982年
ゼラチン・シルバー・プリント
Adrian Panaro
Robert Lewis
1982
Gelatin silver print
35.3 × 27.9 cm

87.
エイドリアン・パナロ
《ミッチェル》
1982年
ゼラチン・シルバー・プリント
Adrian Panaro
Mitchell
1982
Gelatin silver print
35.3 × 27.8 cm

88.
エイドリアン・パナロ
《スティーブン》
1982年
ゼラチン・シルバー・プリント
Adrian Panaro
Steven
1982
Gelatin silver print
35.3 × 27.9 cm

89.
エイドリアン・パナロ
《ジェニファー》
1982年
ゼラチン・シルバー・プリント
Adrian Panaro
Jennifer
1982
Gelatin silver print
35.4 × 27.8 cm

90.
エイドリアン・パナロ
《アナ・スイ》
1982年
ゼラチン・シルバー・プリント
Adrian Panaro
Anna Sui
1982
Gelatin silver print
35.4 × 27.9 cm

91.
作者不詳
《無題》
制作年不詳
写真
Unknown
Untitled
N/D
Photograph
50.7 × 40.5 cm

92.
作者不詳
《無題》
制作年不詳
写真
Unknown
Untitled
N/D
Photograph
50.8 × 40.5 cm

93.
作者不詳
《無題》
制作年不詳
写真
Unknown
Untitled
N/D
Photograph
50.6 × 40.5 cm

94.
ポール・スタイニッツ
《クリスティーン・ミング》
1994年
プラチナ・プリント
Paul Steinitz
Christine Ming
1994
Platinum print
47.9 × 39.0 cm

95.
エドワード・メイプルソープ
《メロディ》
1988年
ゼラチン・シルバー・プリント
Edward Mapplethorpe
Melody
1988
Gelatin silver print
25.2 × 22.0 cm

96.
ブリジット・ポレミス
《モハメド・アリ》
2010年
キャンバスにペイント
Brigitte Polemis
Muhammad Ali
2010
Paint on canvas
120.2 × 120.1 cm

97.
ジーニー
《無題》
制作年不詳
キャンバスにペイント
Genie
Untitled
N/D
Paint on canvas
61.0 × 60.7 cm

98.
ジーニー
《無題》
制作年不詳
キャンバスにペイント
Genie
Untitled
N/D
Paint on canvas
60.8 × 60.6 cm

99.
スコット・リフシュルツ
《無題》
2004年
キャンバスにペイント
Scott Lifschultz
Untitled
2004
Paint on canvas
61.5 × 61.1 cm

100.
サイ・ロス
《芸者》
制作年不詳
キャンバスにペイント
Cy Roth
Geisha
N/D
Paint on canvas
173.0 × 172.5 cm

101.
ベビー・グレガー
《ポートレート》
1994年
板にペイント
Baby Gregor
Portrait
1994
Paint on wood board
38.4 × 38.4 cm

102.
ベビー・グレガー
《木板に描かれた顔》
制作年不詳
板にペイント
Baby Gregor
Faces on Wood Panel
N/D
Paint on found wood board
38.2 × 13.3 cm

103.
リーヴィス・アイトル
《容赦なきミング》
2008年
キャンバスにペイント
Reavis Eitel
Ming the Merciless
2008
Paint on canvas
45.5 × 45.5 cm

*104.
キャット・ルース
《無題》
1983年
キャンバスにペイント
Katt Ruth
Untitled
1983
Paint on canvas
142.3 × 86.5 cm

*105.
ピエール・シャンドラ
《無題》
制作年不詳
パネルにペイント
Pierre Chandra
Untitled
N/D
Paint on wood board
88.2 × 57.0 cm

*106.
エドワード・ダンコナ
《ハリウッド・ピンナップガール》
制作年不詳
ポスター
Edward D'Ancona
Hollywood Pinup Girl
N/D
Poster
50.4 × 40.6 cm

107.
アンドレ・ウォーカー
《無題》
1983年頃
パステル、水彩、紙
Andre Walker
Untitled
c. 1983
Pastel and watercolor on paper
23.0 × 30.9 cm

108.
作者不詳
ザ・ハウス・オブ・デュプリー主催のボールプログラム
の表紙
1986年
印刷物
Unknown
Cover of Paris is Burning Ball Program, organized
by the House of Dupree
1986
Printed paper
25.3 × 20.1 cm

109.
フィリス・ディラー
《ヴィクトリア》
制作年不詳
紙にペイント
Phyllis Diller
Victoria
N/D
Paint on paper
32.4 × 40.0 cm

110.
ステラ
《聖母マリア》
制作年不詳
キャンバスにペイント
Stella
Mary
N/D
Paint on canvas
40.5 × 30.5 cm

111.
アーロン・ポッツ
《愛の贈り物》
2008年
カラーインク、紙
Aaron Potts
The Gift of Love
2008
Color ink on paper
35.5 × 28.0 cm

*112.
作者不詳
《無題》
制作年不詳
キャンバスにペイント
Unknown
Untitled
N/D
Paint on canvas
152.5 × 122.0 cm

*113.
作者不詳
《無題》
制作年不詳
キャンバスにペイント
Unknown
Untitled
N/D
Paint on canvas
125.5 × 181.3 cm

114.
アーロン・コベット
《パトリシア・フィールド》
1998年
Cプリント
Aaron Cobbett
Patricia Field
1998
C-Print
27.9 × 21.4 cm

115.
作者不詳
《無題》
制作年不詳
写真
Unknown
Untitled
N/D
Photograph
32.8 × 27.8 cm

116.
カリン・コールバーグ
《ノー・スモーキング》
2003年
写真
Karin Kohlberg
No Smoking
2003
Photograph
40.5 × 50.7 cm

117.
レオナード
《パトリシア・フィールド》
1999年
キャンバスにペイント
Leonard
Patricia Field
1999
Paint on canvas
101.8 × 106.6 cm

118.
スコット・イーワルト
《パトリシア・フィールド》
2003年
写真
Scott Ewalt
Patricia Field
2003
Photograph
55.8 × 45.8 cm

119.
ダニエル"ディー"コルッチ
《パトリシア・フィールド》
制作年不詳
キャンバスにペイント
Danielle "Dee" Colucci
Patricia Field
N/D
Paint on canvas
76.6 × 61.0 cm

120.
マーカス・レザーデイル
パトリシア・フィールド
1988年
写真
Marcus Leatherdale
Patricia Field
1988
Photograph
32.5 × 27.8 cm

121.
パトリック・マクマラン
《パトリシア・フィールド》
制作年不詳
写真
Patrick McMullan
Patricia Field
N/D
Photograph
17.6 × 12.6 cm

122.
ドン・パトロン
《ビッグ・レッド》
2007年
紙にペイント
Don Patron
Big Red
2007
Paint on Paper
17.8 × 12.8 cm

123.
ワンダ・アコスタ
《パトリシア・フィールド、インドシン・ニューヨーク》
2010年
写真
Wanda Acosta
Patricia Field, Indochine NY
2010
Photograph
26.0 × 35.4 cm

124.
進藤祐光
《パトリシア・フィールド》
1994年
Cプリント
Yuko Shindo
Patricia Field
1994
C-Print
25.3 × 30.5 cm

125.
オーラン
《パトリシア・フィールドのポートレート》
制作年不詳
板にペイント
Olan
Portrait of Patricia Field
N/D
Paint on wood board
101.8 × 76.0 cm

126.
森田彩愛
《ハッピー・バースデー》
2015年
紙にドローイング
Sae Morita
Happy Birthday
2015
Drawing on paper
29.5 × 21.0 cm

127.
ブランドン・オルソン
《私の自由の女神》
制作年不詳
紙にペイント
Brandon Olson
My Statue of Liberty
N/D
Paint on paper
27.4 × 18.0 cm

128.
イザベル・リタ
《無題》
2006年
キャンバスにペイント
Isabelle Lita
Untitled
2006
Paint on canvas
50.7 × 40.1 cm

129.
ポール・スタイニッツ
《無題》
2000年
プラチナ・プリント
Paul Steinitz
Untitled
2000
Platinum print
27.9 × 37.7 cm

130.
ポール・スタイニッツ
《無題》
2000年
プラチナ・プリント
Paul Steinitz
Untitled
2000
Platinum print
37.4 × 28.1 cm

131.
ポール・スタイニッツ
《無題》
2000年
プラチナ・プリント
Paul Steinitz
Untitled
2000
Platinum print
38.0 × 28.5 cm

132.
ポール・スタイニッツ
《無題》
2000年
プラチナ・プリント
Paul Steinitz
Untitled
2000
Platinum print
28.1 × 37.8 cm

133.
ノエル・スアレス
《ラ・パット・フィールド》
2003年
キャンバスにペイント
Noel Suarez
La Pat Field
2003
Paint on canvas
91.3 × 76.0 cm

134.
作者不詳
サラ・ジェシカ・パーカーとパトリシア・フィールド
2000年頃
写真
Unknown
Sarah Jessica Parker and Patricia Field
c. 2000
Photograph
12.7 × 17.3 cm

135.
作者不詳
パトリシア・フィールド
制作年不詳
写真
Unknown
Patricia Field
N/D
Photograph
22.6 × 19.9 cm

136.
作者不詳
パトリシア・フィールド
制作年不詳
写真
Unknown
Patricia Field
N/D
Photograph
40.5 × 50.3 cm

137.
作者不詳
パトリシア・フィールド
制作年不詳
写真
Unknown
Patricia Field
N/D
Photograph
45.2 × 50.0 cm

コラージュクレジット
Collage Credit

pp. 28-29

1. Codie Ravioli, graphic for the store window, designed by Artie Hach and Reiko Lauper
2. David Dalrymple for House of Field fashion show, c. 2000
3. Ayumi and Nashom at Wigstock
4. Ayumi and Jun Nakayama
5. Patricia Field and Sheeba, c. 1980
6. Store ad sticker
7. Eve and David Dalrymple at David Dalrymple for House of Field fashion show, c. 2000
8. Hotel Venus storefront, c. 2000
9. House of Field group photo, 1995
10. From left to right: Unknown, Tobell Von Cartier, Richie Rich at House of Field fashion show, 1997
11. Nashom and Maria, Hotel Venus store postcard, designed by Scott Ewalt
12. Patricia Field at Hotel Venus
13. Connie Fleming and Keith Haring at The Pyramid, Photo by ©Tom Enbanks, c. 1990
14. Store moving sign
15. Perfidia's wig salon ad card, designed by Scott Ewalt
16. Sultana
17. From left to right: Mars Roberge, Mayu, Unknown at Hotel Venus
18. House of Field fashion show, in front of the 8th Street store, 1995
19. Patricia Field and Masuko Kato
20. Patricia Field and David Dalrymple
21. Hotel Venus store postcard, designed by Scott Ewalt
22. Baby Mary and Patricia Field
23. Ayumi and coworkers going to the House of Field fashion show, 1995
24. Amanda Lepore at House of Field fashion show, c. 2000
25. Model at David Dalrymple for House of Field fashion show, c. 2000
26. Connie Fleming, from *FACE Magazine*, Photo by ©Andrew MacPherson, c. 1990
27. 8th Street storefront, c. 2000
28. Paul Alexander, Jojo Americo, Nashom (The Ones), screenshot from "Flawless" music video
29. Hotel Venus store postcard designed by Scott Ewalt
30. Perfidia's wig salon business card
31. House of Field fashion show, in front of the 8th Street store, 1995
32. Employees at Hotel Venus
33. Unknown, Paolo Nieddu, unknown at Hotel Venus

Courtesy of

Santiago Felipe: 24, 27, 35
Reiko Lauper: 3, 6, 8, 9, 13, 16, 19, 22, 23, 26, 28, 30, 32, 38, 39, 40
Ayumi Mitsuishi: 11, 20, 31
Verushka Music: 2, 14
Mz. Neon: 10, 21
Tatsuya Shoji: 7
Store Archive: 1, 4, 5, 12, 15, 17, 18, 25, 29, 33, 34, 36, 37

1. Christmas Spectacular store flyer, designed by Reiko Lauper, 2009
2. From left to right: Kerin Rose, Lyndsay, Moto, Verushka Music, Amanda Lepore, Julie, 2008
3. Ingrid Nilson at Patricia's hair salon, 2012
4. Dai Burger and Will Noguchi from Patricia Field's Instagram, 2021
5. From left to right: Moto, Molly Rogers, Unknown, Sushi, Patricia Field at *Sex and the City 2* Premiere after party, 2010
6. Natalie and Drew Barrymore at 302 Bowery store, 2011
7. Emplyees at 302 Bowery storefront
8. Adam at 302 Bowery storefront, 2011
9. Jonte Moaning and Leo Gugu at 306 Bowery store, 2012
10. Mz. Neon
11. Patricia's house party
12. Store ad for *NEXT Magazine*, designed by Artie Hach and Reiko Lauper, 2009
13. House of Field group photo at ON TOP Party at the Standard Hotel, 2013
14. Codie Ravioli and Verushka Music
15. 302 Bowery store
16. From left to right: Angelina, Masami, Artie Hach, Moto at Patricia Field Halloween party
17. House of Field Varsity Jacket from Patricia Field online store
18. Kyle wearing Patricia Field VOGUE snapback cap
19. Cazwell and Amanda Lepore at Amanda Lepore's BIG TOP party, 2010
20. From left to right: Unknown, Unknown, Unknown, Verushka Music, Gisele Alicea at ABSOLUTE Vodka/PAPER magazine's Fashion Explosion, 583 Park Avenue, October 6, 2008
21. Mz. Neon
22. Barbie and Kyle at My Chiffon is Wet party, Eastern Bloc, 2012
23. Putana (Patricia's dog)
24. RuPaul at RuPaul's Drag Race Season 4 live stream event at 302 Bowery store, 2012
25. The Diet Coke City collection by Patricia Field, 2008
26. Phillipe Blond and Ty Hunter at Patricia Field Halloween Party (STRIPPERS VS. VAMPS), Rick's Cabaret, 2013
27. From left to right: Dai Burger, Russian Dennis, Angelina at RuPaul's Drag Race Season 4 live stream event at 302 Bowery store, 2012
28. Codie Ravioli and Andre J at 302 Bowery store, 2011
29. 302 Bowery store
30. From left to right: Reiko Lauper, Hiraku Morilla, Ayumi at 302 Bowery storefront, 2012
31. Paris Hilton and Ayumi at 302 Bowery store
32. 302 Bowery store, 2010
33. RuPaul's Drag Race Season 4 live stream event flyer, 2012
34. Keith Haring by House of Field graphic for the online store, designed by Julie Hardee, 2008
35. Dai Burger at RuPaul's Drag Race Season 4 live stream event at 302 Bowery store, 2012
36. From left to right: Guy, Kiara Timothy, Will Noguchi (from left to right) from Patricia Field's Instagram, 2019
37. Patricia Field Swim-sational Disco Soiree at 230 Fifth store flyer, design by Reiko Lauper, 2010
38. Russian Dennis and Ayako at Patricia Field Halloween party
39. Kari (Patricia's cat, adopted by Reiko later) at 306 Bowery store, 2015
40. Patricia Field and Miley Cyrus at Miley's concert backstage, 2015

写真クレジット
Photography Credits

謝辞
Acknowledgements

本書の刊行にあたり、格別のご協力を賜りました下記の関係者の方々、並びにここにお名前を記すことを差し控えさせていただいた方々に、心よりお礼を申し上げます。
（敬称略、アルファベット順）

ジョジョ・アメリコ
アーリーン・Z・アヤリン
デイビッド・ダルリンプル
コニー・フレミング
エリカ・グスマン
アーティ・ハック
ケビン・マクヒュー
三石あゆみ
フシダール・モルテザイ
ヴェルーシュカ・ミュージック
ミズ・ニオン
マイケル・ロビンソン
庄司達也
アネックス・ソン
臼杵杏希子
レベッカ・ワインバーグ

We would like to express our sincere gratitude to the following people and whose names we have withheld here for their cooperation in the publication of this book.
(Titles omitted, in alphabetical order)

Jojo Americo
Arhlene Z. Ayalin
David Dalrymple
Connie Fleming
Erica Guzman
Artie Hach
Kevin McHugh
Ayumi Mitsuishi
Hushidar Mortezaie
Verushka Music
Mz. Neon
Michael Robinson
Tatsuya Shoji
Annex Song
Akiko Usuki
Rebecca Weinberg

展覧会

「ハウス・オブ・フィールド」展
2023年6月3日（土）― 2024年5月6日（月）
中村キース・ヘリング美術館

主催：中村キース・ヘリング美術館
特別協力：パトリシア・フィールド・アートファッション
後援：米国大使館

企画・構成：田中今子
シニアアドバイザー：梁瀬薫
翻訳：ヒラク
学芸補：石垣駿太
施工：有限会社ディスプレイ遠藤
広報物デザイン：レイコ・ローパー
広報：島田裕子、木虎春香

カタログ

パトリシア・フィールド・アートコレクション
「ハウス・オブ・フィールド」
2023年8月15日 初版発行

執筆：岸雅代、梁瀬薫
進行：田中今子
編集：梁瀬薫、ヒラク、石垣駿太
編集協力：押金純士
翻訳：ヒラク、ダン・ウィバー
校正：小野冬黄、ジェーン・バラーズ
デザイン：レイコ・ローパー

レイコ・ローパー
イラストレーター／グラフィックデザイナー
1982年東京生まれ。
東京造形大学彫刻科を卒業後、2006年からニューヨークに在住。
2008年から2015年の間、パトリシア・フィールドの専属グラフィックデザイナーを担当。店舗フライ
ヤーからパトリシア個人のプロジェクトまで様々なグラフィックを手掛け、退社後はアートギャラリー勤
務の後、2019年に独立。グラフィックデザイナー、イラストレーター（IllustrationX 在籍）として、現
在もニューヨークで活動中。
reikolauper.com | Instagram: @reikolauper

発行者: 中村和男（中村キース・ヘリング美術館 館長）
発行: 中村キース・ヘリング美術館
〒408-0044　山梨県北杜市小淵沢町10249-7
www.nakamura-haring.com

Exhibition

The House of Field
June 3, 2023 — May 6, 2024
Nakamura Keith Haring Collection

Organized by Nakamura Keith Haring Collection
Special Cooperation by Patricia Field ARTFashion
In Association with U.S. Embassy Tokyo

Curator: Imako Tanaka
Senior Advisor: Kaoru Yanase
Translation: Hiraku Morilla
Curatorial Assistant: Shunta Ishigaki
Construction: Display Endo Ltd.
Publicity Material Design: Reiko Lauper
PR: Yuko Shimada, Haruka Kitora

Catalog

Patricia Field Art Collection
"The House of Field"
First Published in Japan in August 15, 2023

Text: Masayo Kishi, Kaoru Yanase
Production Manager: Imako Tanaka
Editing: Kaoru Yanase, Hiraku Morilla, Shunta Ishigaki
Editorial Coordinator: Junji Oshigane
Translation: Hiraku Morilla, Dan Wever
Proofreader: Fuyuki Ono, Jane Baraz
Designer: Reiko Lauper

Reiko Lauper
Illustrator/Graphic Designer
Born in Tokyo in 1982.
Lives in New York since 2006 after graduating from Tokyo Zokei University with a BFA
in sculpture.
Reiko worked as an exclusive graphic designer for Patricia Field from 2008–2015 and was
responsible for designing all the store graphics, including flyers and Patricia's personal
projects. After leaving the company, she worked at a local art gallery and then ventured into
an independent career. She is currently active in a wide range of creative fields, from graphic
design to illustration(represented by IllustrationX) in New York City.
reikolauper.com | Instagram: @reikolauper

Publisher: Kazuo Nakamura
(Founder of Nakamura Keith Haring Collection)
Publication Company: Nakamura Keith Haring Collection
10249-7 Kobuchizawa, Hokuto City Yamanashi Prefecture,
408-0044, Japan
www.nakamura-haring.com